I eat

one pomelo a month

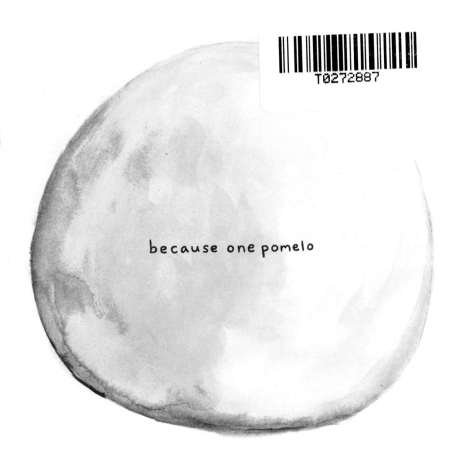

because one pomelo

takes one month to eat

for the first three weeks

it waits on the counter

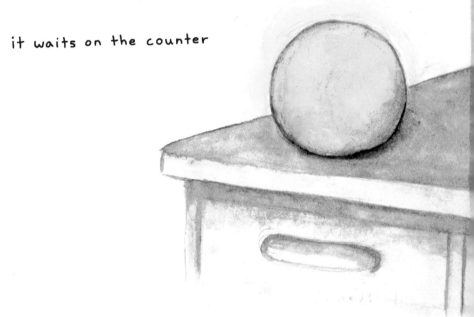

where I can smell

its sweet greenness

as I pass

2

I don't plan what night

I eat the pomelo

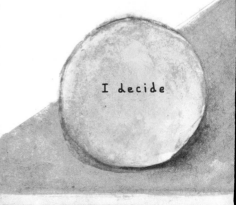

I decide

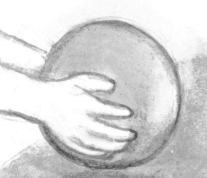

the moment

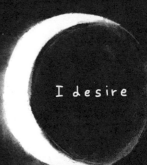

I desire

to feed my demon

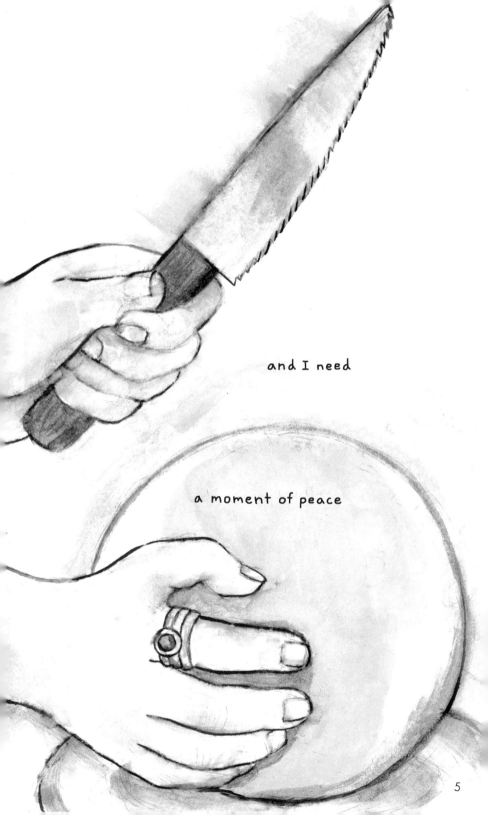

and I need

a moment of peace

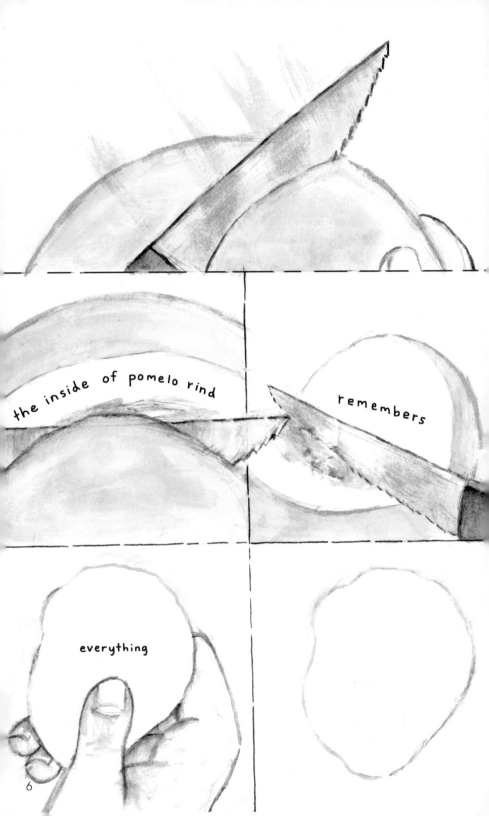

the inside of pomelo rind

remembers

everything

6

I watch

the shed skin

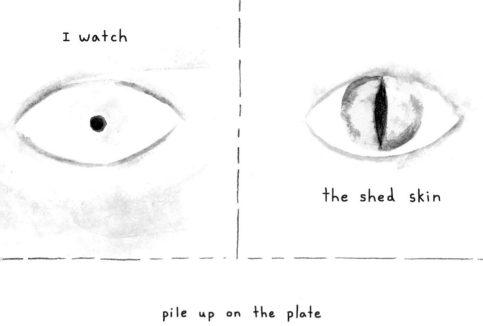

pile up on the plate

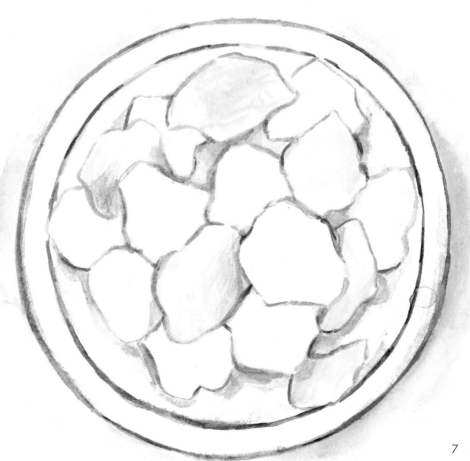

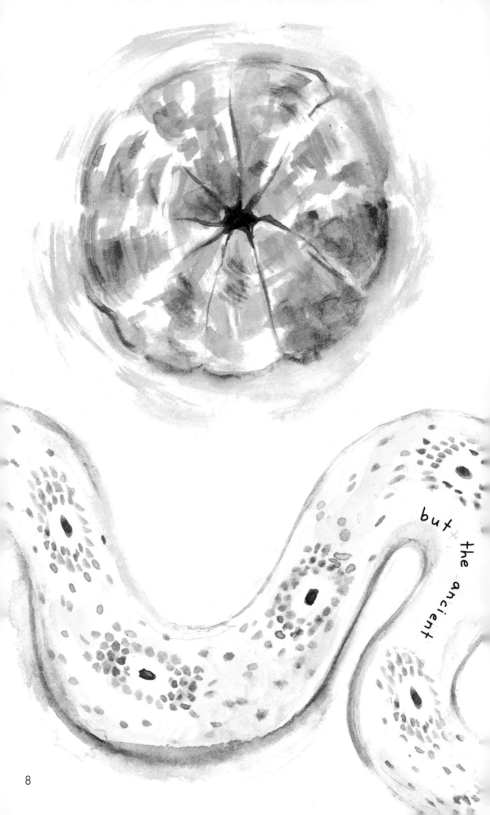

but the ancient

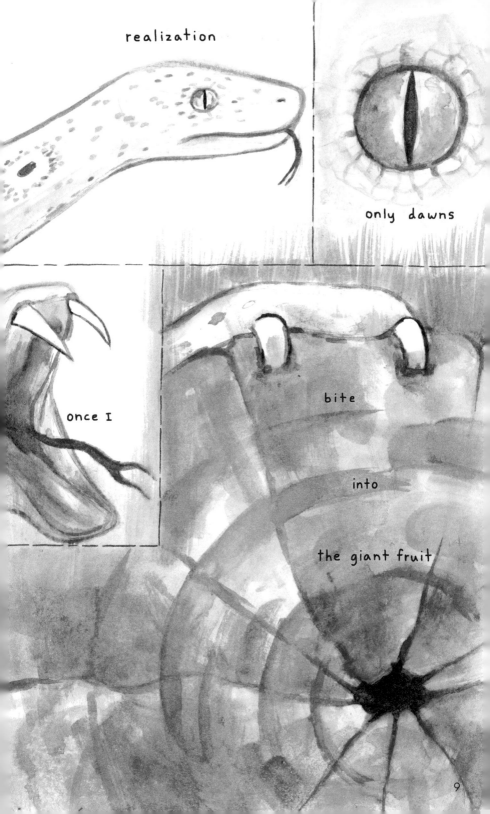

realization

only dawns

once I

bite

into

the giant fruit

9

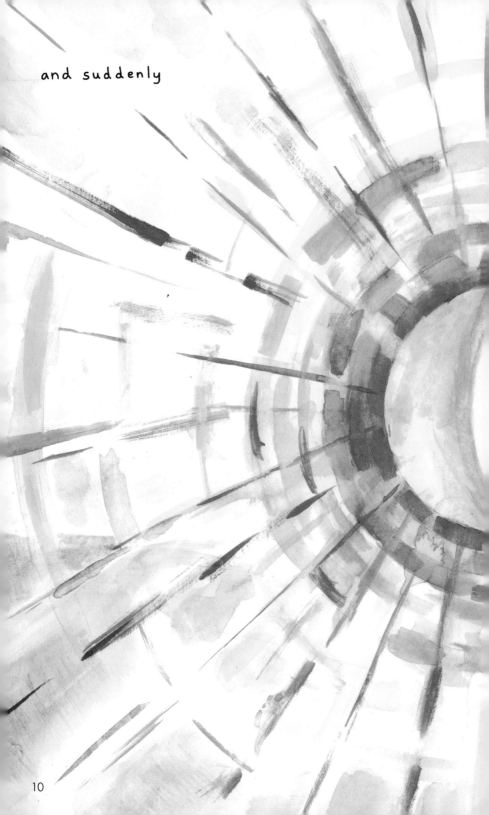

and suddenly

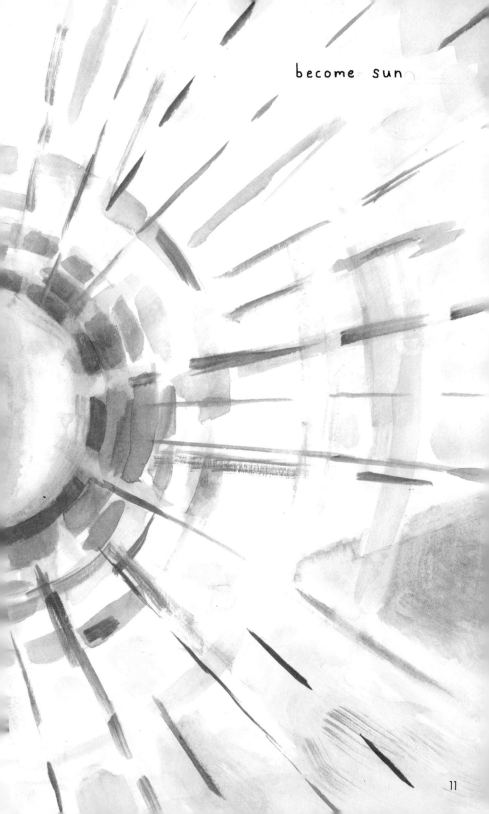

become sun

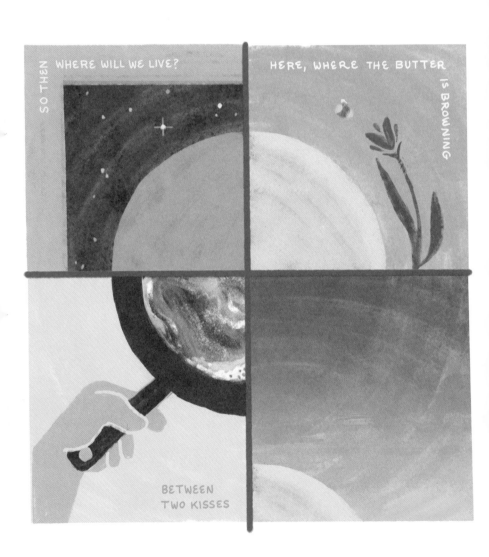

SO THEN WHERE WILL WE LIVE?

HERE, WHERE THE BUTTER IS BROWNING

BETWEEN
TWO KISSES

12 Madeleine Witt | Love Poem

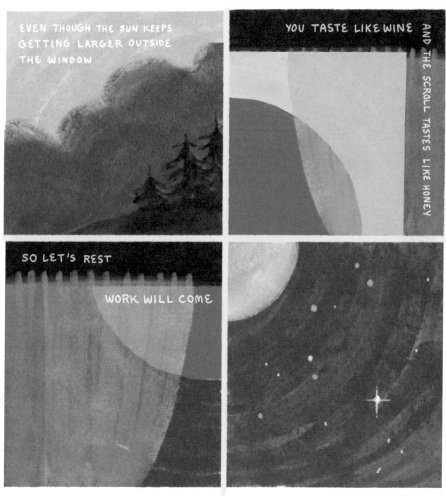

EVEN THOUGH THE SUN KEEPS
GETTING LARGER OUTSIDE
THE WINDOW

YOU TASTE LIKE WINE

AND THE SCROLL TASTES LIKE HONEY

SO LET'S REST

WORK WILL COME

WITH THE MORNING

World Models

Can agents learn inside of their own dreams?

DAVID HA Google Brain Tokyo, Japan
JÜRGEN SCHMIDHUBER NNAISENSE
MARCH 27 2018
NIPS 2018 Paper
Youtube Talk
Download PDF

the greenery
 the soft and the sharp
 the quickness of the shiver, the tremble
 in the wind.

Are rocks alive?
 yes, of course!

Rock mites?
Rock dust?
 Thick grit, the motes, the motion
 the heavy motion, the nesting particles

Wet trees in the grey light
Wet roots, wet rocks
mist floats, a gentle drifting weight

Wet rocks, wet thoughts
Even I am alive.

A Gentle Introduction to the Challenge of Training Deep Learning Neural Network Models

By Jason Brownlee on February 15, 2019 in Better Deep Learning

A naive algorithm ███████████ is likely to become misled, lost, and ultimately stuck,

███████████, as they naively follow along the error gradient ███████ more art than science.

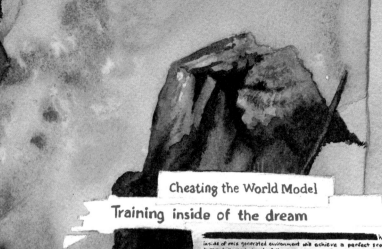

Cheating the World Model

Training inside of the dream

Whatever ▇ learned inside of this generated environment will achieve a perfect score ▇▇ most of the time, but will obviously fail when unleashed into the harsh reality of the actual world, underperforming ▇▇

to break — break down, break apart
 suffused in a syrup of perceived failure

it is water, it is wet, it is
 Everything, vibrating, all matter vibrates
 Even slowly, even slowly — I vibrate

I tear apart in wet shreds
 jammy clumps of
 throat and chest dissolving

I want to melt into the mud.

Who names our patterns?

Every moment we exist we reconstruct them
Wet patterns, wet light
Wet quiet

the minds we program
paint the dream, paint the thought
working awake, working asleep

On discrete actions causing imperfections in the world model

Teaching agents to paint inside their own dreams

Reiichiro Nakano
@Reii Yoda

Wet blur of simulated watercolor
then through my memory to make literal with paint
a flash of light to approximate the pixels
Replicated color

then inked in passes, line by line,
to replicate again —

that color of the imagined

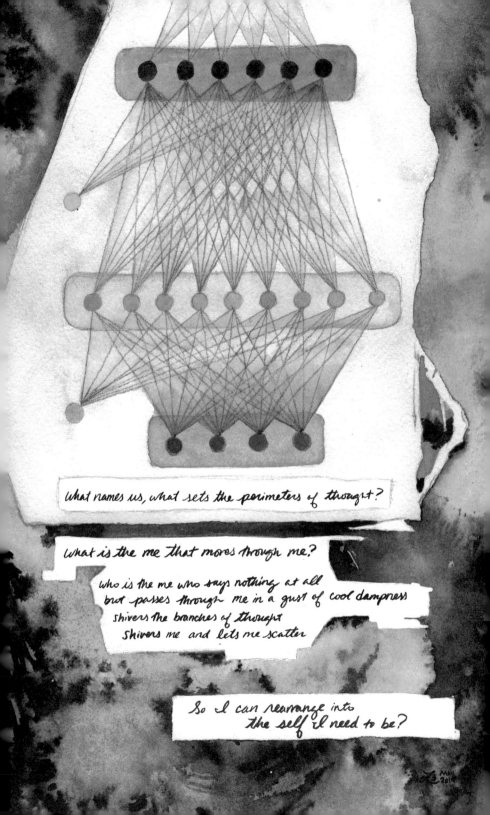

What names us, what sets the perimeters of thought?

What is the me that moves through me?

who is the me who says nothing at all
but passes through me in a gust of cool dampness
shivers the branches of thought
shivers me and lets me scatter

So I can rearrange into
the self I need to be?

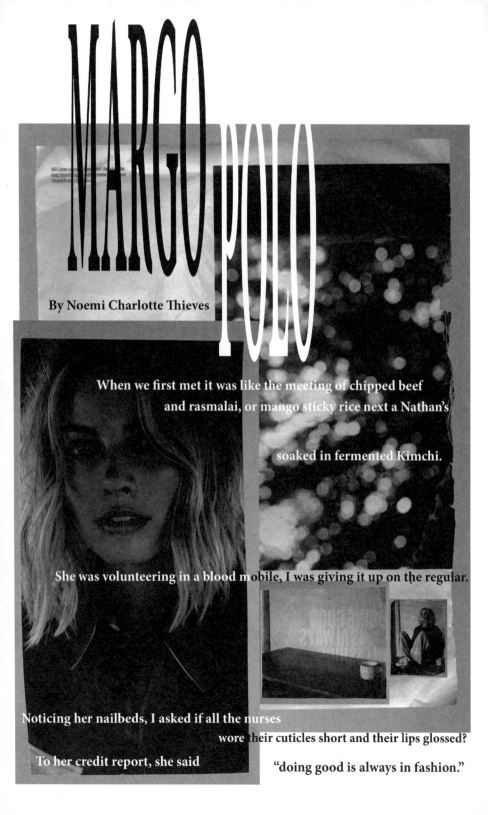

MARGO POLO

By Noemi Charlotte Thieves

When we first met it was like the meeting of chipped beef
and rasmalai, or mango sticky rice next a Nathan's

soaked in fermented Kimchi.

She was volunteering in a blood mobile, I was giving it up on the regular.

Noticing her nailbeds, I asked if all the nurses
wore their cuticles short and their lips glossed?

To her credit report, she said

"doing good is always in fashion."

Even made up a faux Prince song in her memory

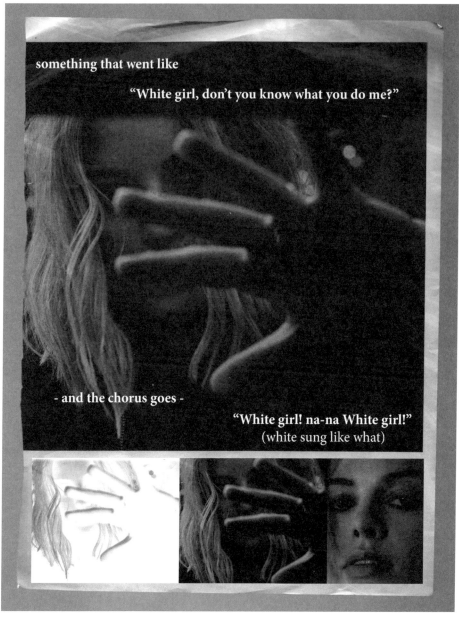

something that went like

"White girl, don't you know what you do me?"

- and the chorus goes -

"White girl! na-na White girl!"
(white sung like what)

But she wasn't white -no- more spiked Georgia peach cobbler

with hair like Mississippi Straw,

very much how I liked my coffee, Pale and bitter-sweet.

We met at an accident site, she just flew out the car
and into my lap.

She laughed at my smile and my calm eyes, said I looked like a

woman from Pompeii, cool under pressure

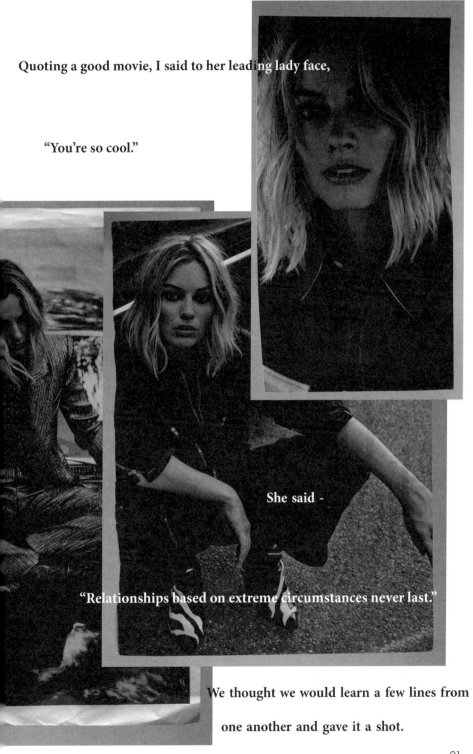

Quoting a good movie, I said to her leading lady face,

"You're so cool."

She said -

"Relationships based on extreme circumstances never last."

We thought we would learn a few lines from

one another and gave it a shot.

Much too cool for school, but not for leather.

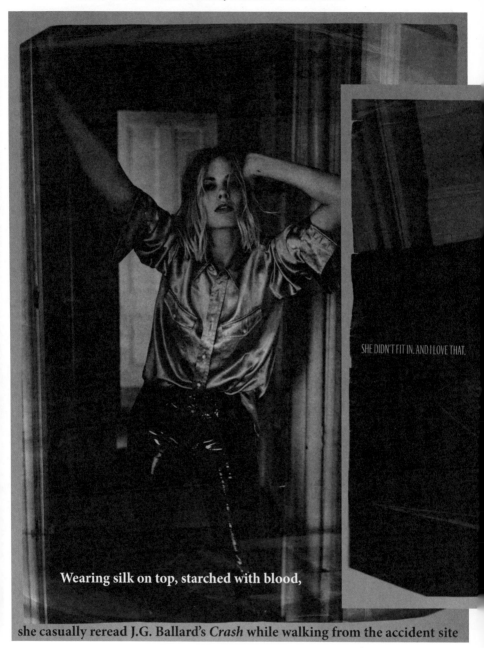

SHE DIDN'T FIT IN. AND I LOVE THAT.

Wearing silk on top, starched with blood,

she casually reread J.G. Ballard's *Crash* while walking from the accident site

where she lost the Honda named Craig, after the list.

Leading lady love, we grew up, she filled out,

a lease, that is,

and together we selected from the pantones and swatches

the paint and paper to cover our concrete commode,

a home we called the cove of washed up cool.

I said the following to my therapist,

"SOME I CAN SHAKE OFF VERY EASILY.
BUT I'M STILL NOT DONE WITH HER."

Who looked at the ceiling for a minute of mine, then

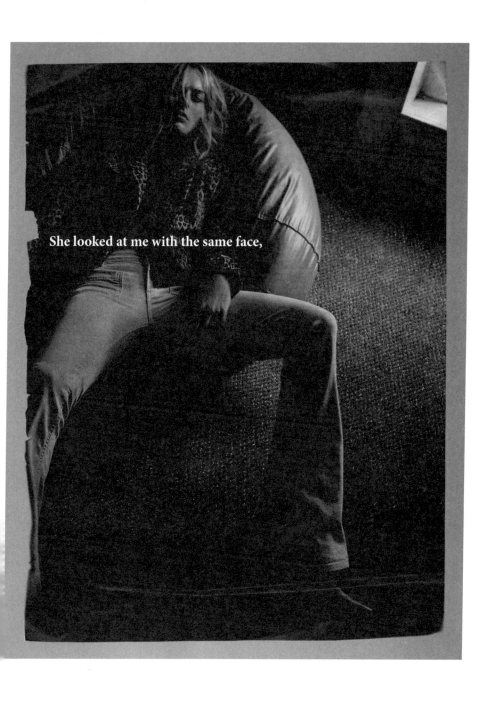

She looked at me with the same face,

a minx mixed of contempt and outrage, behind a skimpy surface ease.

There was still that understanding she would disappear,

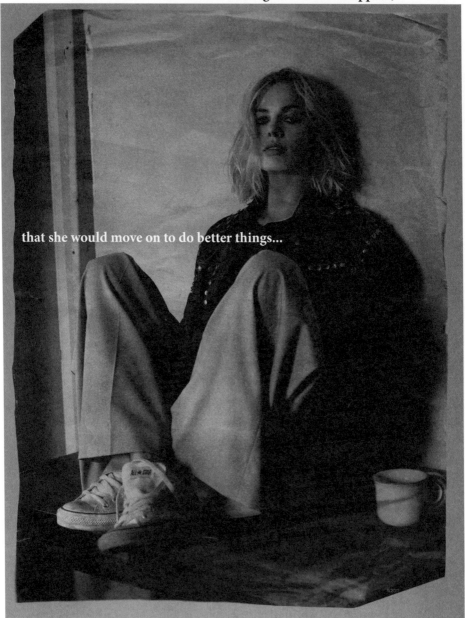

that she would move on to do better things...

I would hate to give her the last word, but

She was right when she said that

G

B
D

O O

Y

E.

A PLANE
LANDS

A PLANE
TAKES OFF

I

TH S.

S
NG O

W I D

P

LIPS

UT

TO
FLU

TE.

REMIND ME!

T
REES
MAKE
PA
PER

(THIS IS
PAPER)

S
M
O
K
E
M
A
K
E S
I
N

K.

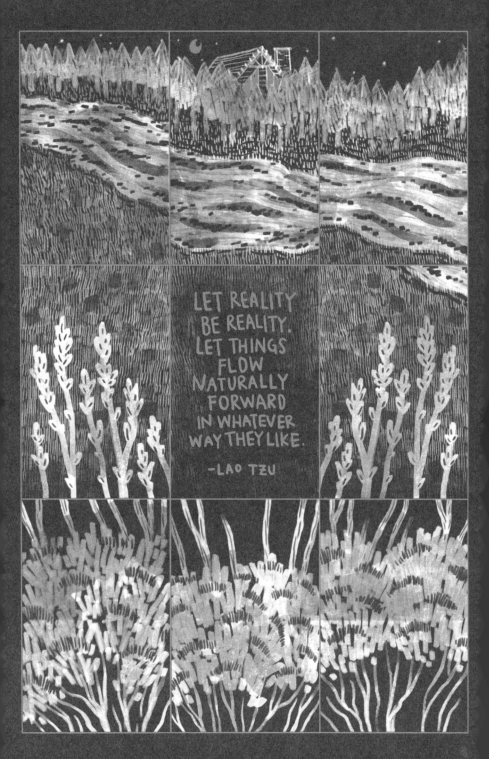

LET REALITY
BE REALITY.
LET THINGS
FLOW
NATURALLY
FORWARD
IN WHATEVER
WAY THEY LIKE.

—LAO TZU

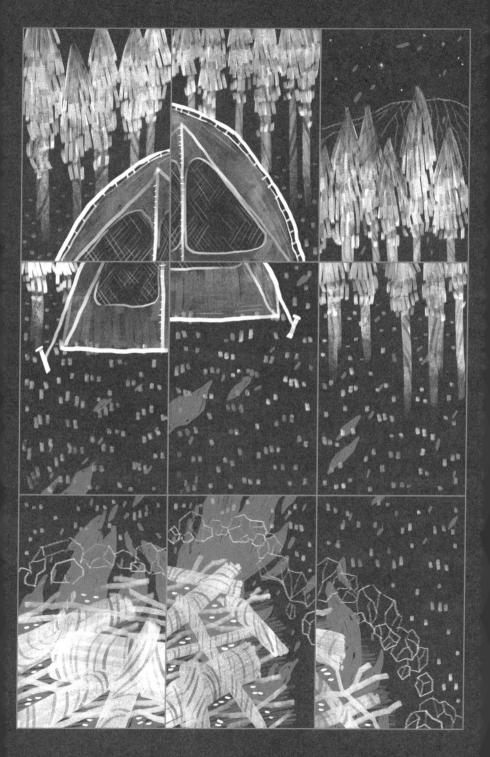

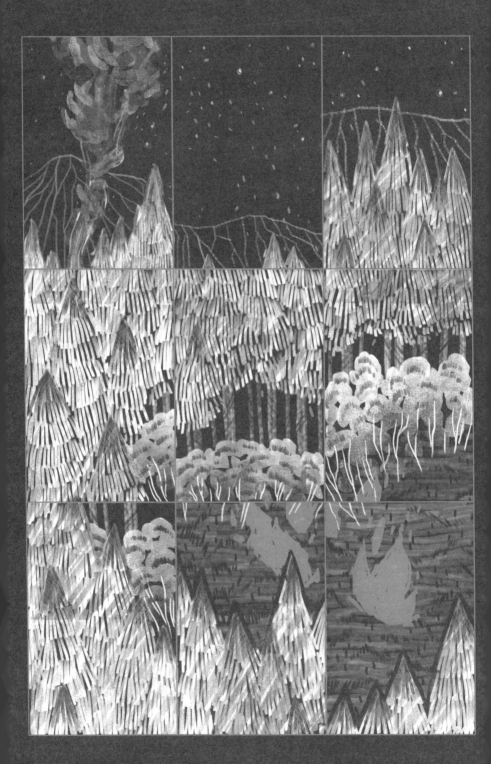

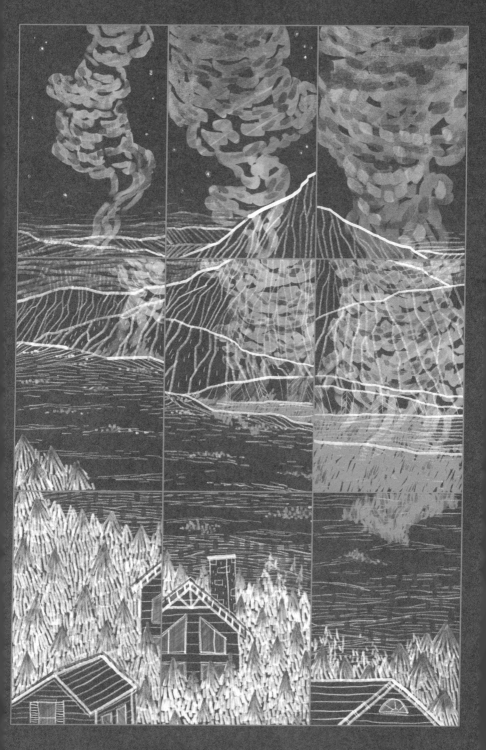

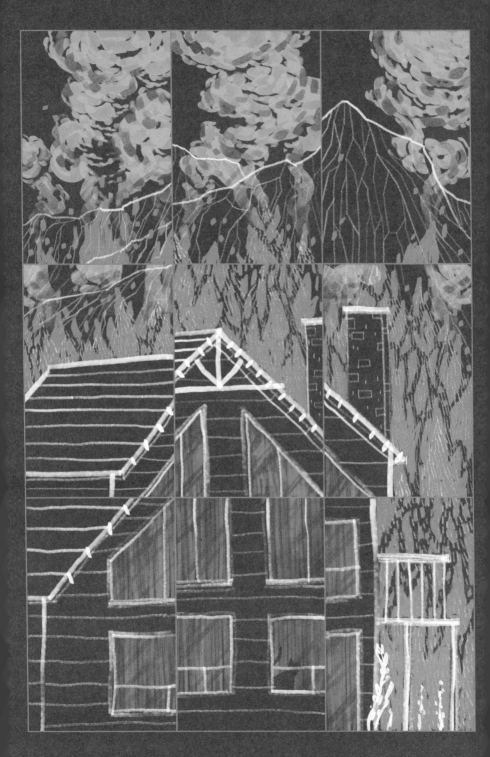

38

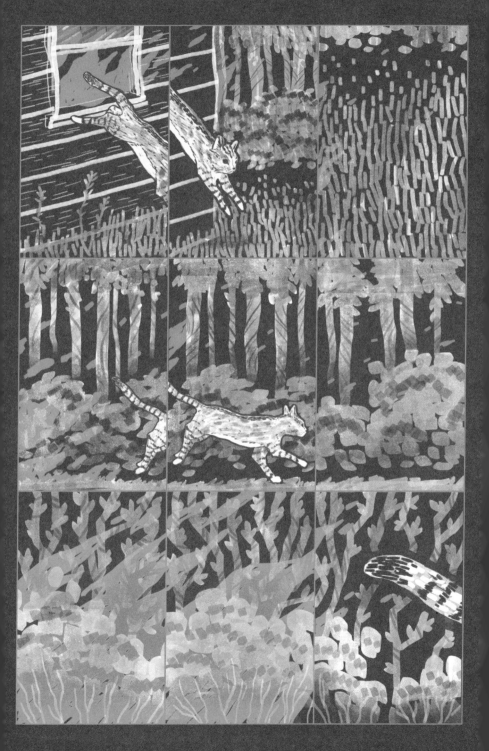

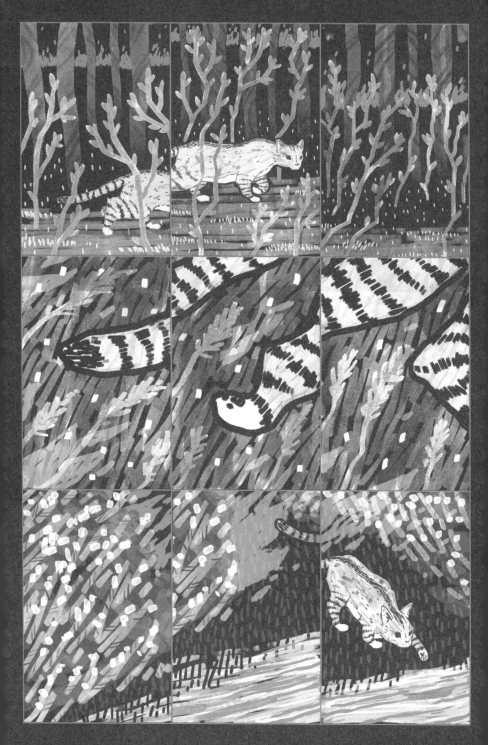

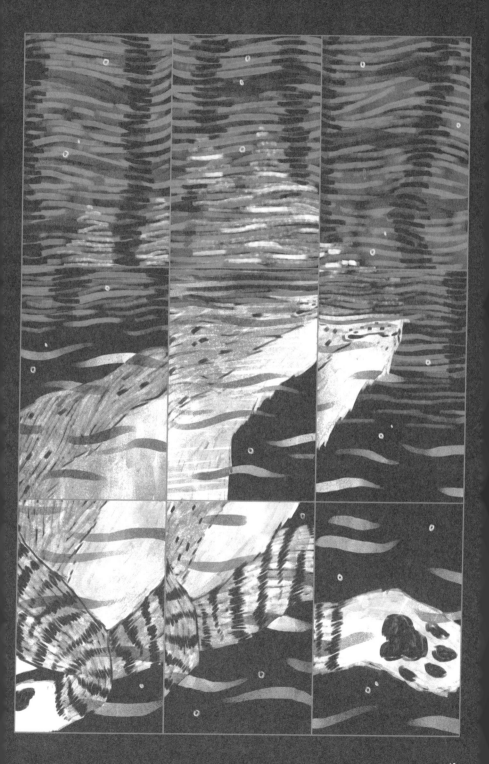

43

44

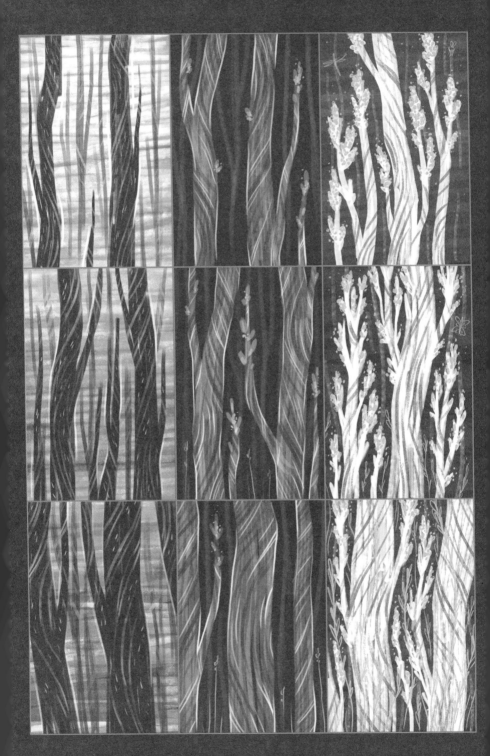

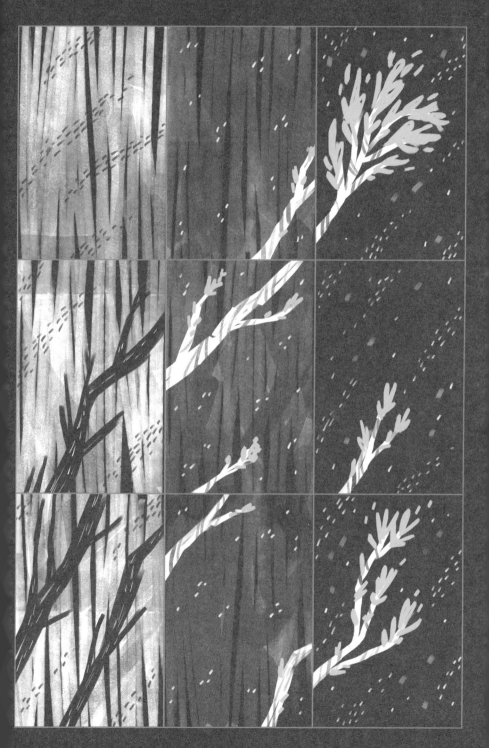

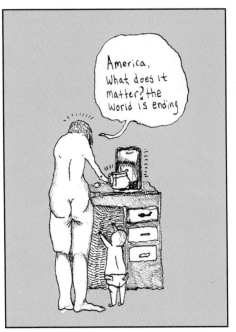

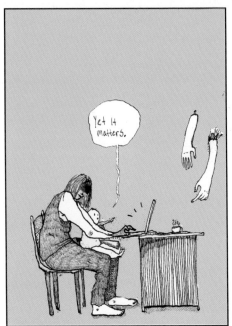

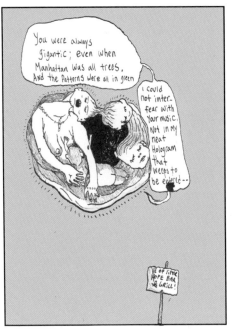

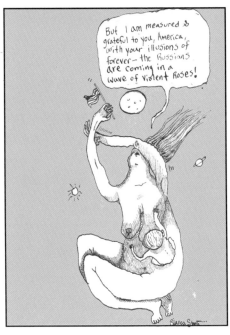

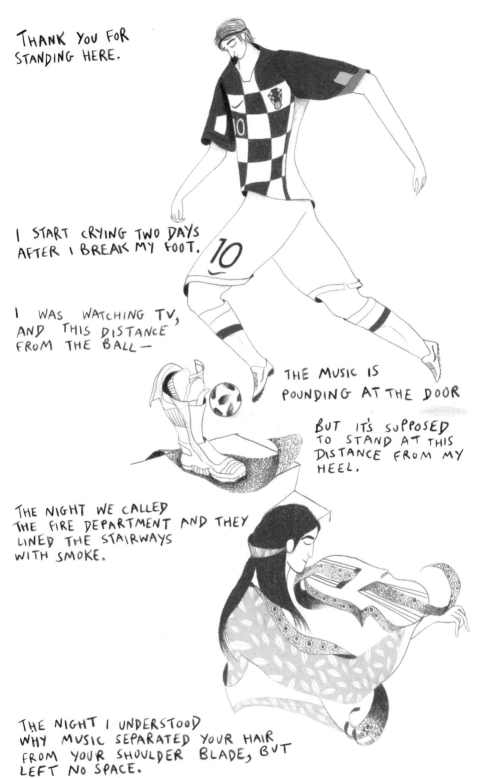

THANK YOU FOR STANDING HERE.

I START CRYING TWO DAYS AFTER I BREAK MY FOOT.

I WAS WATCHING TV, AND THIS DISTANCE FROM THE BALL —

THE MUSIC IS POUNDING AT THE DOOR

BUT IT'S SUPPOSED TO STAND AT THIS DISTANCE FROM MY HEEL.

THE NIGHT WE CALLED THE FIRE DEPARTMENT AND THEY LINED THE STAIRWAYS WITH SMOKE.

THE NIGHT I UNDERSTOOD WHY MUSIC SEPARATED YOUR HAIR FROM YOUR SHOULDER BLADE, BUT LEFT NO SPACE.

WHENEVER YOU REACH FOR
SOMETHING IN YOUR ROOM,

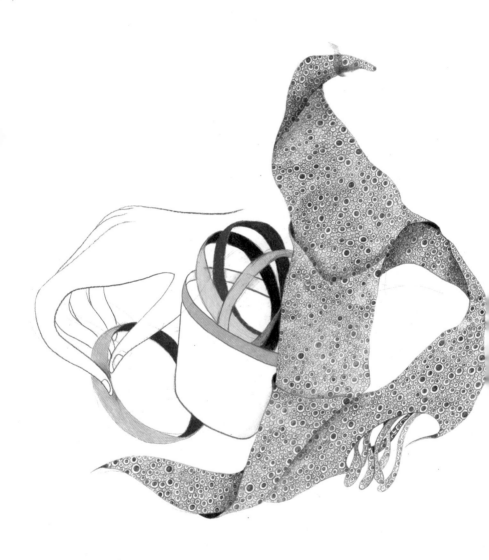

IT FEELS METALLIC.

THE SIZE OF A METAL RULER
THAT FLEXES WHEN IT BECOMES
TOO LONG,

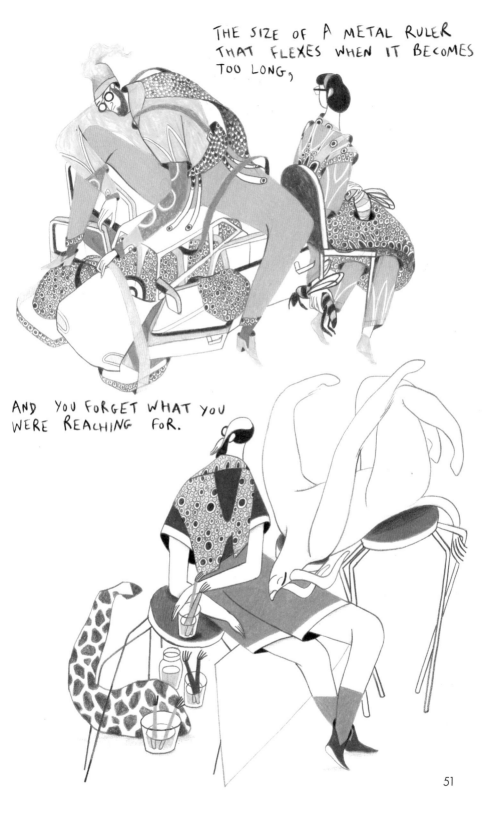

AND YOU FORGET WHAT YOU
WERE REACHING FOR.

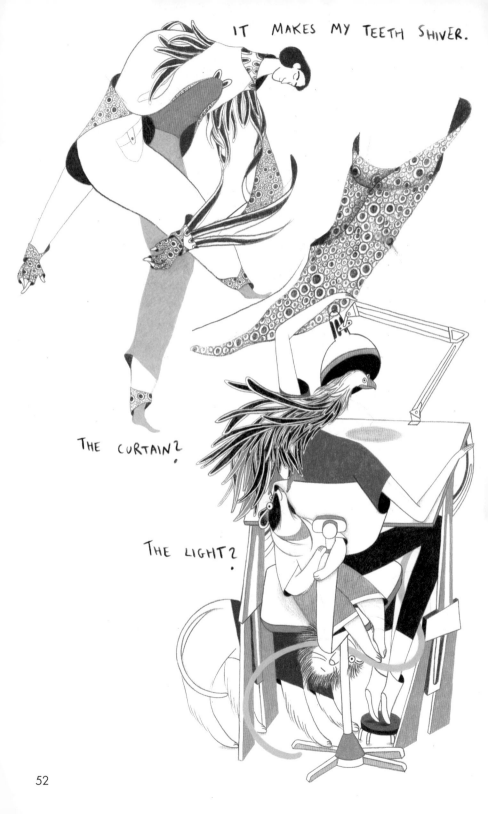

IT MAKES MY TEETH SHIVER.

THE CURTAIN?

THE LIGHT?

52

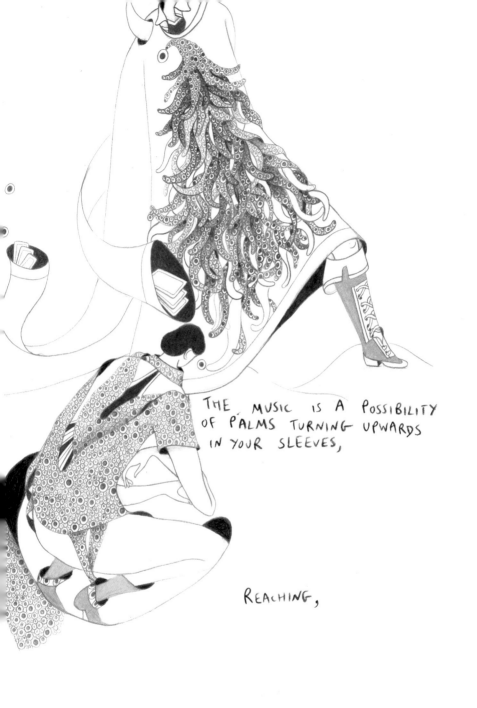

THE MUSIC IS A POSSIBILITY
OF PALMS TURNING UPWARDS
IN YOUR SLEEVES,

REACHING,

IMMEASURABLY.

A SELECTION OF WALKING
STICKS ARE ADDED TO THE ROOM.

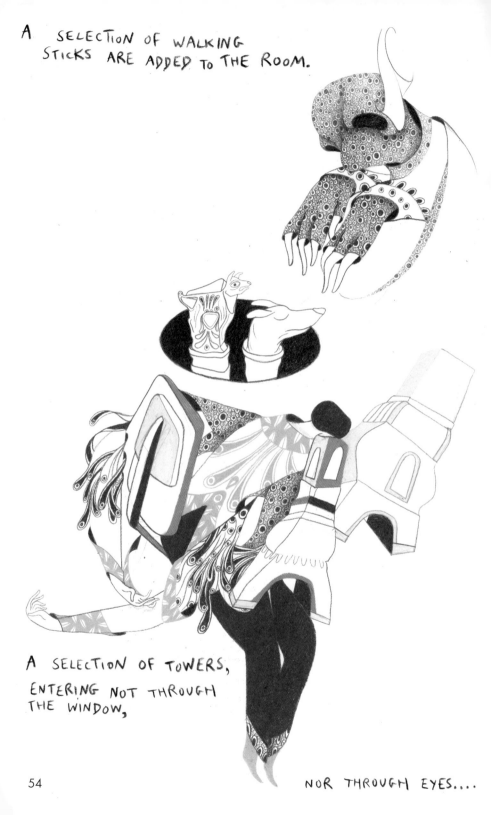

A SELECTION OF TOWERS,
ENTERING NOT THROUGH
THE WINDOW,

NOR THROUGH EYES....

A HUNGER FOR INSECTS TO MARK THIS MOMENT WHEN MY TEETH AREN'T HURTING.

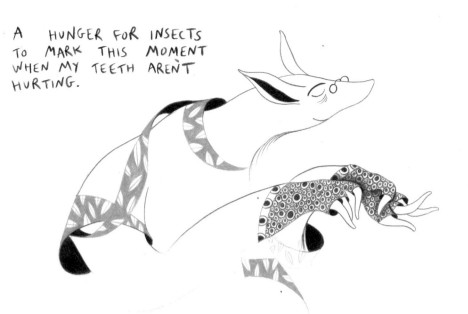

I WANT TO BITE DOWN ON A SMALL EXOSKELETON,

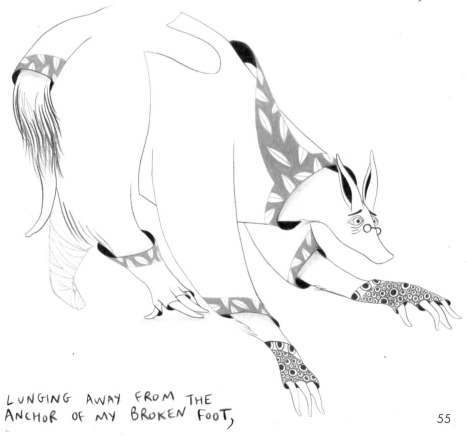

LUNGING AWAY FROM THE ANCHOR OF MY BROKEN FOOT,

55

MY HUNGER LEADS ME TO
A GARDEN OF THE MEASUREMENTS
WHICH ESCAPED YOUR ROOM,

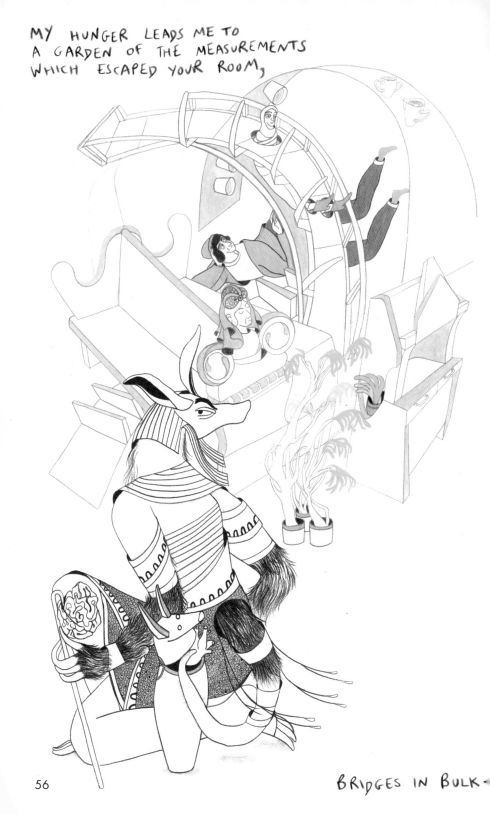

BRIDGES IN BULK.

- WHICH YOU SNAP OFF YOUR
 COAT RACK EVERY TIME YOU
 RUSH OUT.

I WILL NEVER KNOW THE SIZE
OF YOUR COAT, UNLESS YOU
REACH FOR IT,

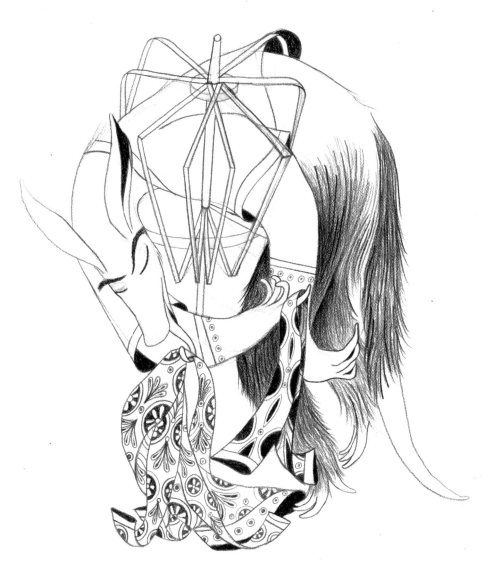

AND THEN, DON'T LEAVE.

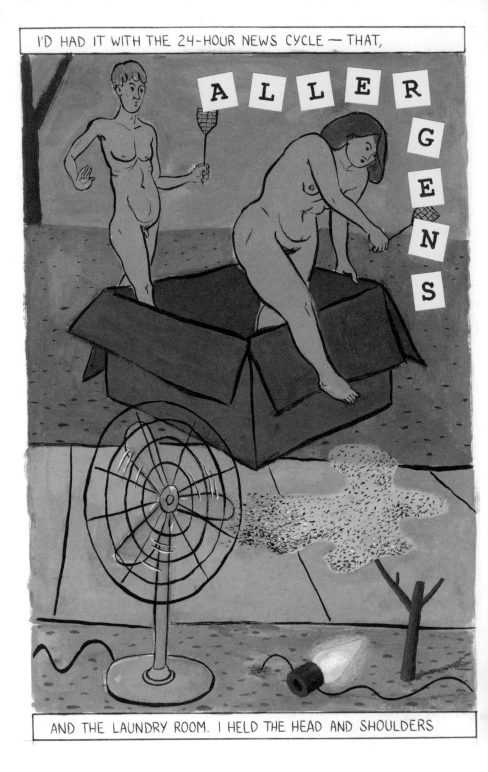

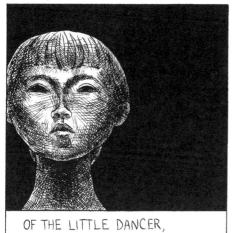

OF THE LITTLE DANCER,

A CARELESS LITTLE COPY,

UPSIDE DOWN,

WAGGING THE FELTED

BOTTOM OF THE BASE,

SLUMPING CORNERS NOW

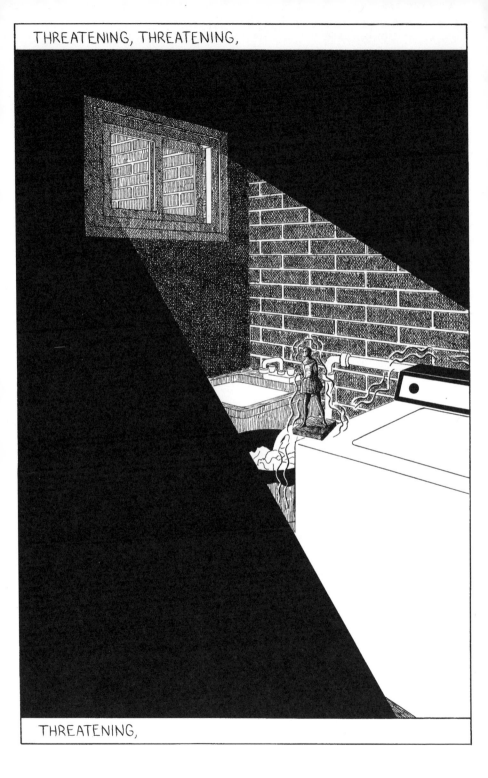

THREATENING,

60

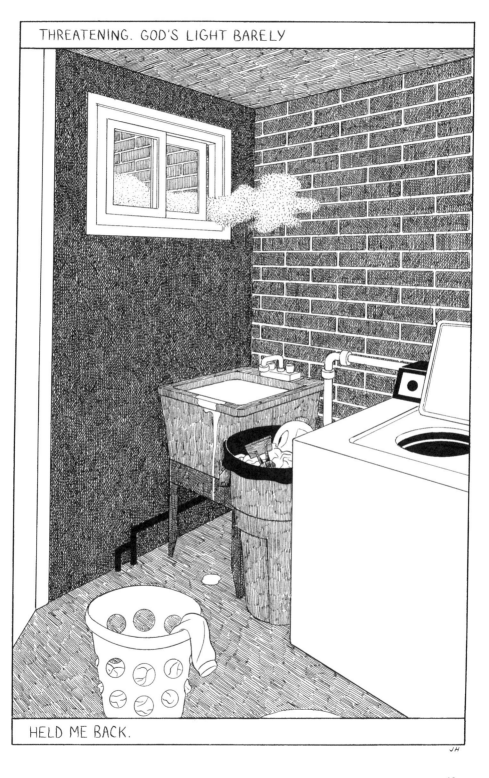

HELD ME BACK.

EXPRESSIONS OF JOY

The mini-comics printed on the following 5 pages represent a sample of some of the experiments and exercises we perform at The Sequential Artists Workshop (SAW).

We start with a blank 8-page folded booklet, and then begin adding either text or marks (brush + ink, paint, pen—whatever is around.)

We derive text from song lyrics (you can see one used twice here) or other sources like Charles Darwin's *The Expression of the Emotions in Man and Animals*, also seen here.

Since the print here is small, I'll transcribe a few favorite snippets: "Is laughter ever carried to such an extreme to bring tears into the eyes?"; "Do the children when sulky, pout or greatly protrude their lips?"; and simply, "Low spirits, anxiety, grief, dejection, despair."

Sometimes these comics start with a single drawing or series of marks. We often pass the booklet around the room, to be further developed, or sometimes keep one book to ourselves (as students Amanda Green and Emma Jensen did) after it gets started with someone else's first random detail, like a title, a cover, pasted text, a first mark, etc.

These are some of my favorite exercises to do at SAW and the comics printed here represent some favorite results. But if you're looking for more, we've collected dozens more that may hopefully make their way to the visible world.

Or you may just have to visit.

TOM HART,
SEQUENTIAL ARTISTS WORKSHOP

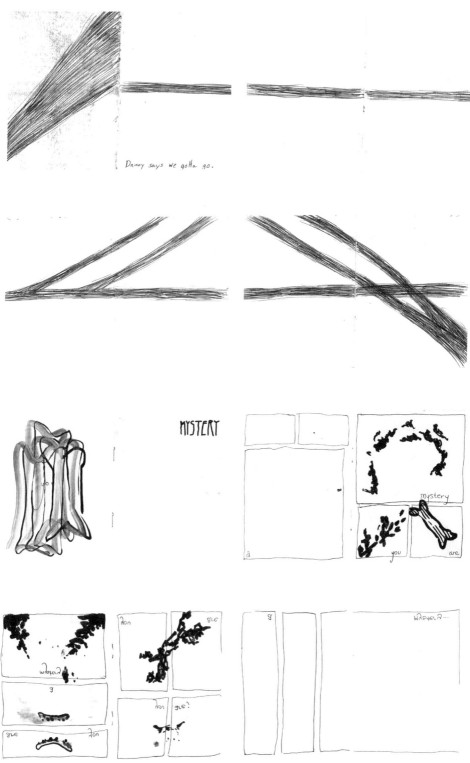

Danny says we gotta go.

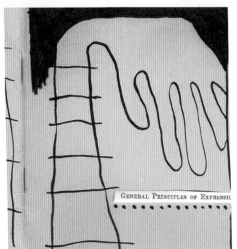

GENERAL PRINCIPLES OF EXPRESSIO

Is laughter ever carried to such an extreme as to bring tears into the eyes?

(14.) Do the children when sulky, pout or greatly protrude the lips?

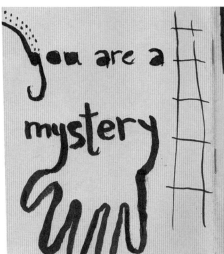

you are a mystery

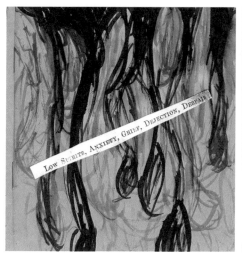

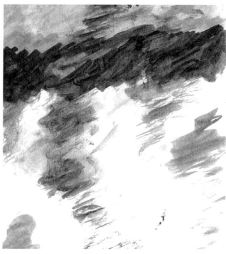

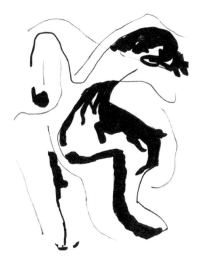

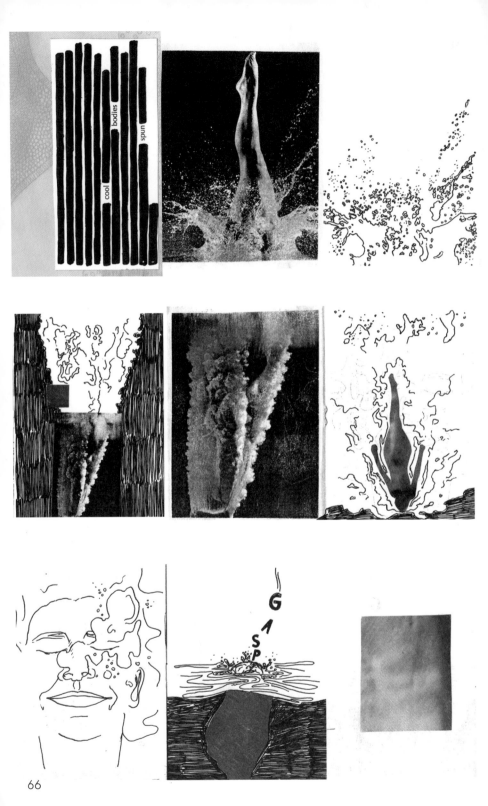

Failed attempt

by
Amanda G

I sat in the waiting room.

I got "counseled" and filled out the forms.

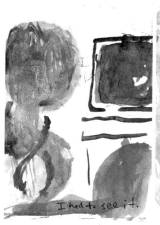

I had to see it.

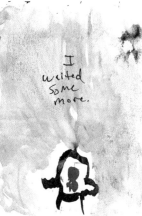

I waited some more.

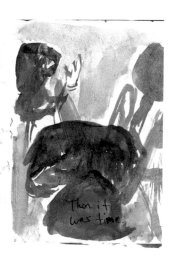

Then it was time.

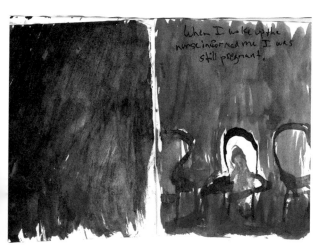

When I woke up the nurse informed me I was still pregnant.

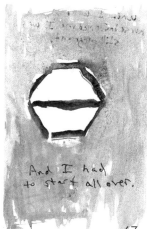

And I had to start all over.

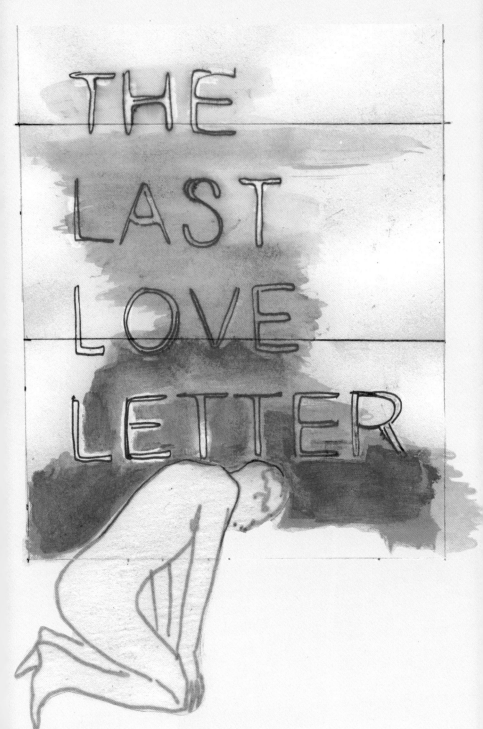

Alyssa Berg

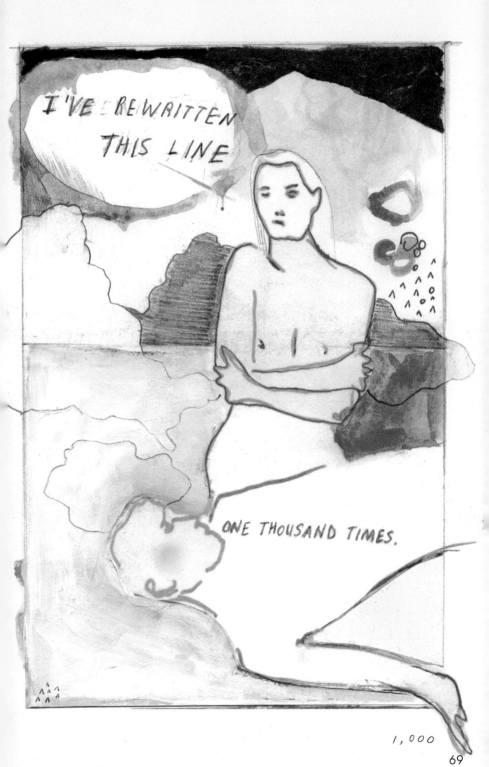

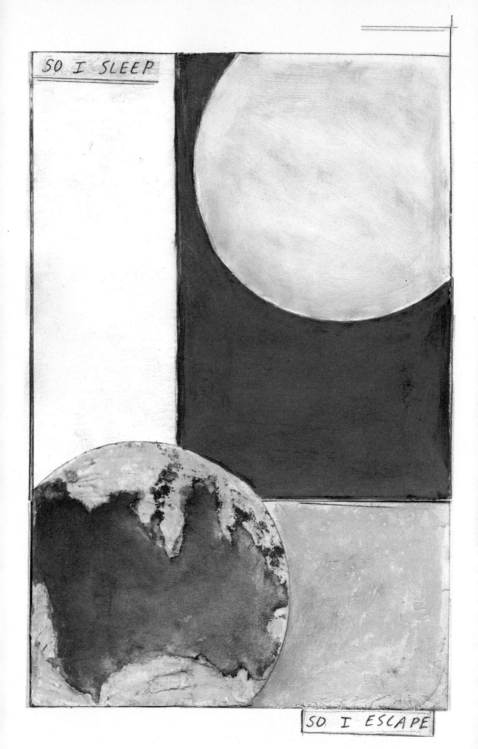

SO I SLEEP

SO I ESCAPE

SO I GO AS FAR AWAY

OR I COME — AS CLOSE AS I CAN

TO THE ENDS OF THE EARTH.

STILL,

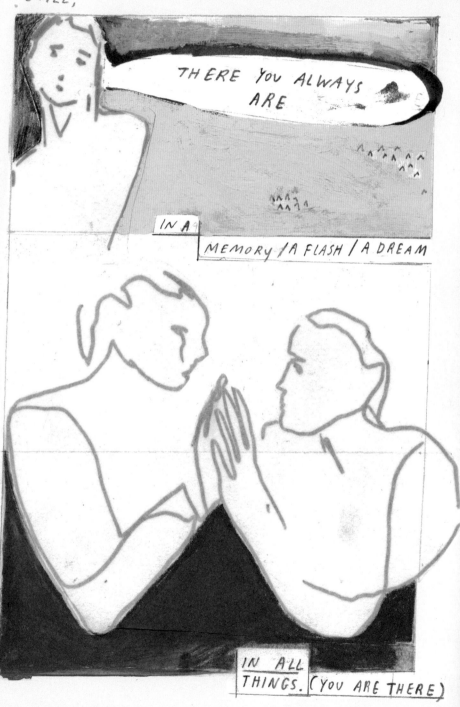

And

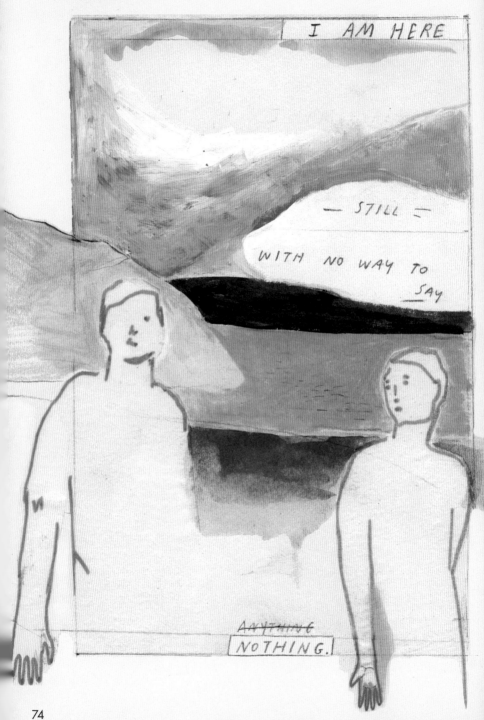

I AM HERE

— STILL —

WITH NO WAY TO SAY

ANYTHING
NOTHING.

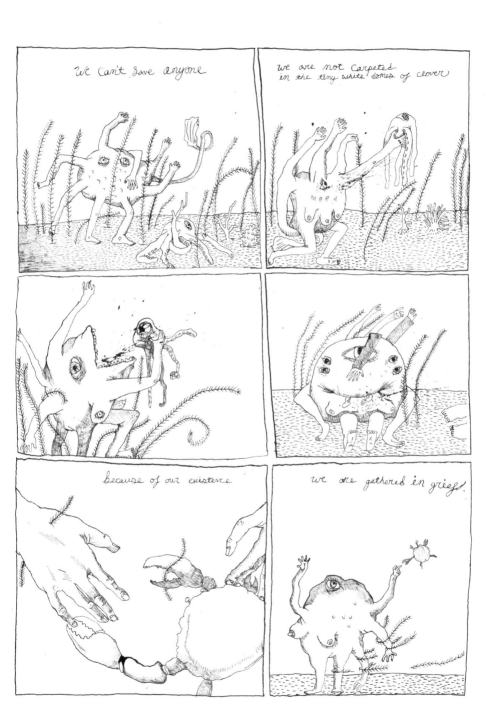

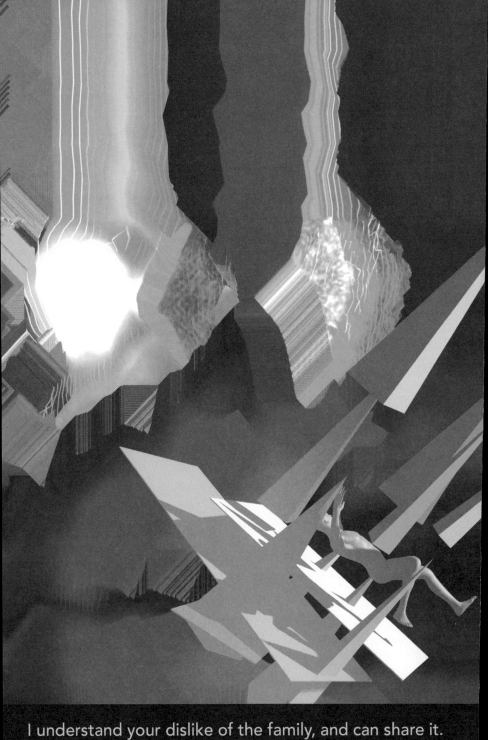

I understand your dislike of the family, and can share it.

Then she said:
I will listen calmly to everything you have to say.

No stranger may go up to the Fortress without a permit.

"Sometimes," said Protagonist, "but there's nothing to suggest that this is one of those times."

Could he perhaps name an official order against him?
Father couldn't.

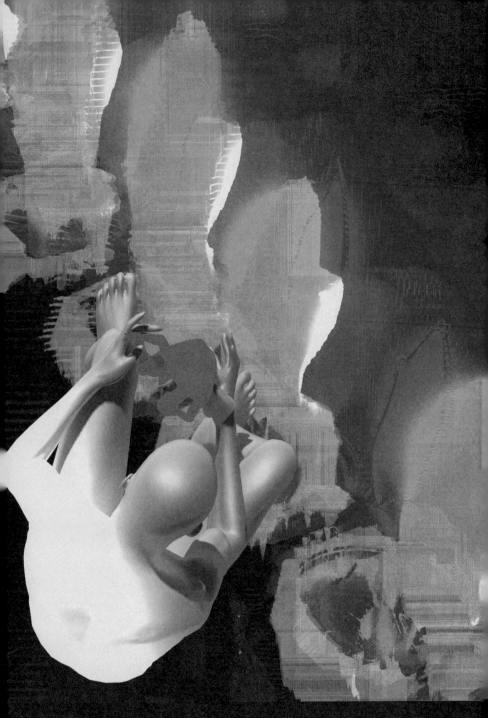

You shouldn't complain, it could happen to anyone.

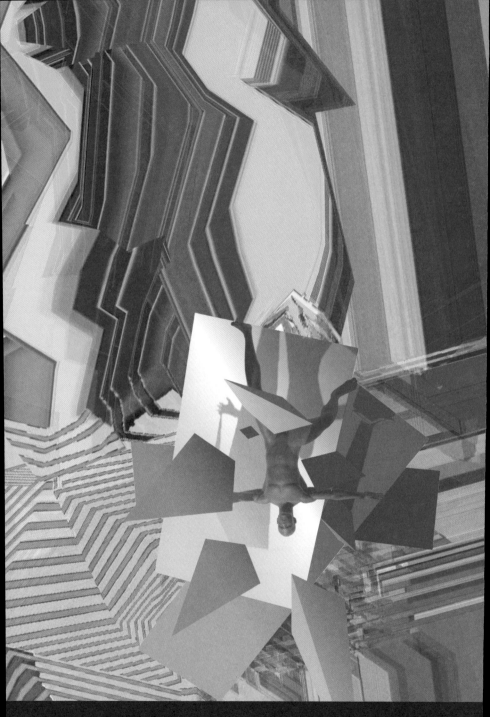

Yet nothing has really happened, except
he has been given a letter for you to deliver.

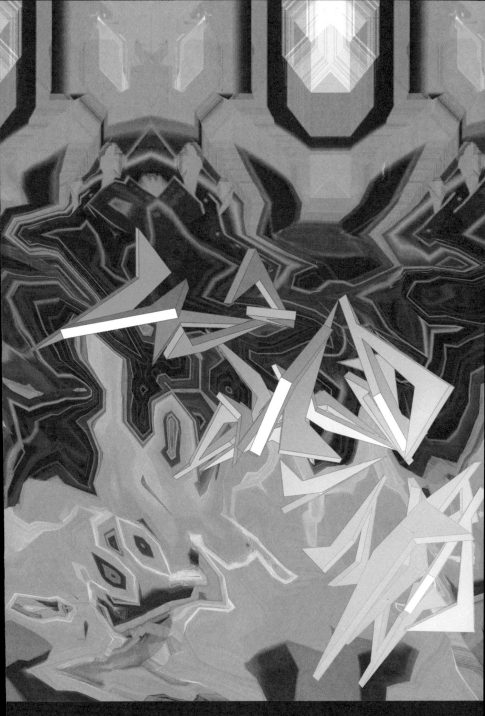

Thereupon loud murmuring, which seemed to indicate approval, came from the other rooms.

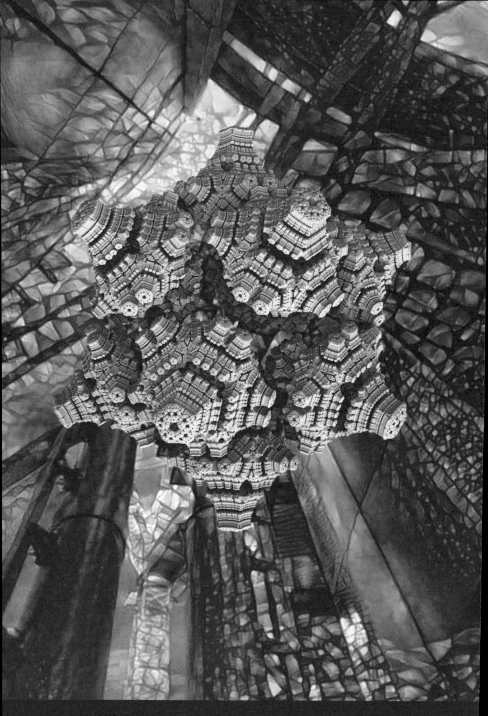

We are not your guardian angels, we're not obliged
to chase after you wherever you go.

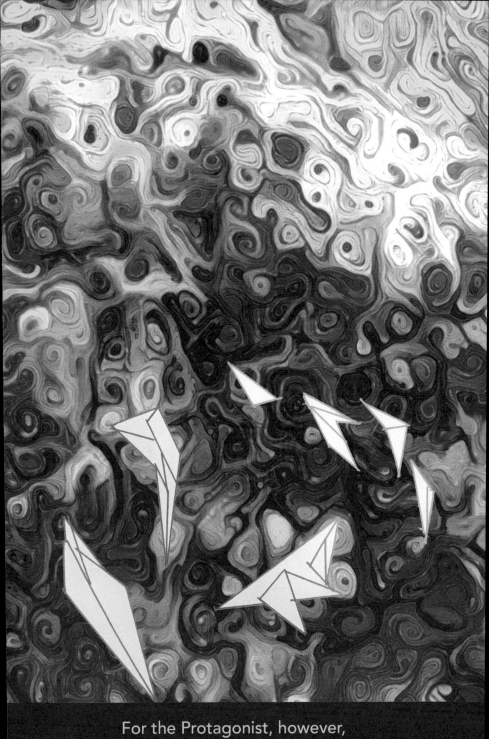

For the Protagonist, however,

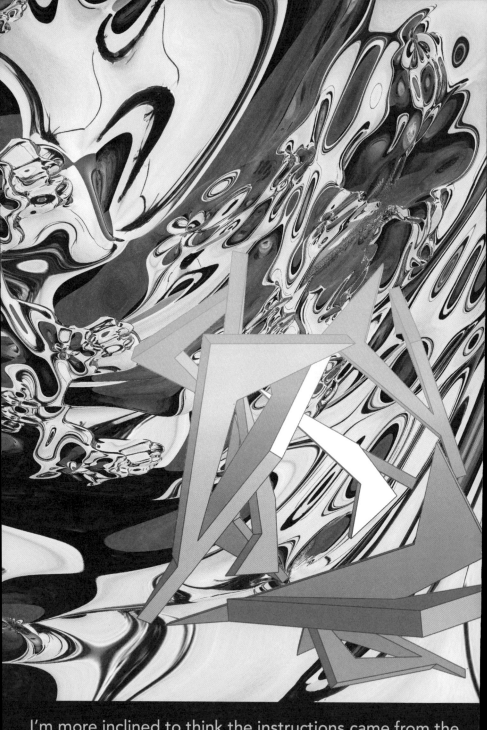

I'm more inclined to think the instructions came from the
Higher authorities.

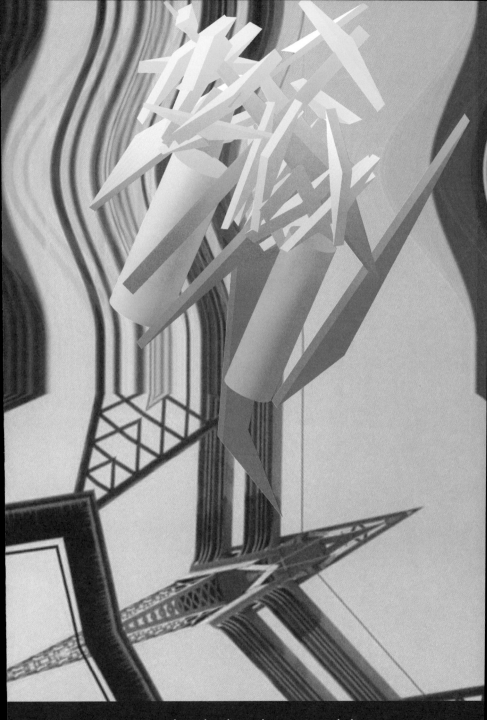

Anyone who doubts that can ask her;
she still loves him today.

CULTIVATED MAN

SANTA CRUZ, CA (1970-1977-AND 1981-1982)

ENDLESS SUNNY DAYS NIPPING HONEYSUCKLES, CHEWING SOURGRASS AND CHAMOMILE, FRESH FROM CRACKS IN RESTAURANT-CLEAN SIDEWALKS

CHASING BUTTERFLIES AND SNIPPING FEET FROM BIRTH CERTIFICATES WITH FAITH

10-SPEED ATTACKS, HANDS STUNG BY BUMBLEBEES AND MYSTERIOUS TROPICAL PLANTS

SEABRIGHT ORANGES, MEDITERRANEAN FIGS AND CHERRY TOMATOES PLUCKT FRESH FOR MOM

WETSUITS DRYING ON ICE PLANTS, AN ISOMETRIC MEMORIAL TO FRIENDS LOST ALONG THE EDGE OF THE WESTERN WORLD

CHEHALIS, WA (1977-1981 AND 1983-1990)

CATCHING SNAKES WITH ZEB, GUM IN HAIR, HANDS BLACK WITH PINE PITCH

STALKING ALIEN CHANTERELLES AND MORELS IN DEEP, DARK RAINFORESTS WITH DAD

KINDLY FOLKS FUMBLE TOWARD SPRING, AS SEASONAL DEPRESSION MAKES THE FLOWERS GROW

HIPSTER FIXIES DODGE LIVING FOSSILS ON GINKGO-SLICKED STREETS

ELECTRIC YELLOW WASPS THROB AND BOB, SIPPING ON TINY NEON BLUE MELTED ICEES

GUATEMALA CITY, GUATEMALA (1987-1988)

LOVELORN AVOCADOS CRASH AND TUMBLE ALONG CORRUGATED ROOVES IN SEARCH OF MEGATHERIA THAT WILL NEVER COME

FIESTA GIRLS SUNTAN THEMSELVES WITH COCA-COLA AMID HIBISCUS RIOTS, ATTRACTING ANTS AND SUITORS

NEW YORK, NY (1990-1993 AND 1998-PRESENT)

EXPLORING PROSPECT'S OASIS, AN ASYMMETRICAL EMERALD SET IN BROOKLYN'S GRAY CONCRETE

AN ANGEL IN SUNSET PARK WAVES GOODNIGHT TO HER OLD LIBERTINE FRIEND, OVER CUBIST AIRBNB CONDOS

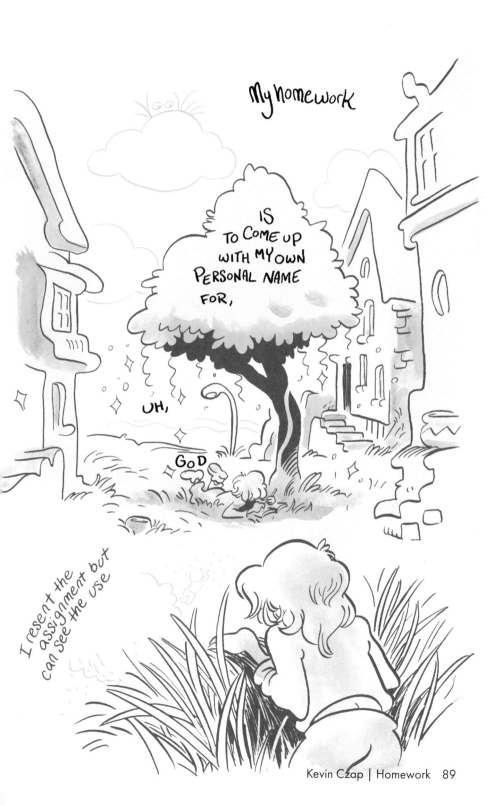

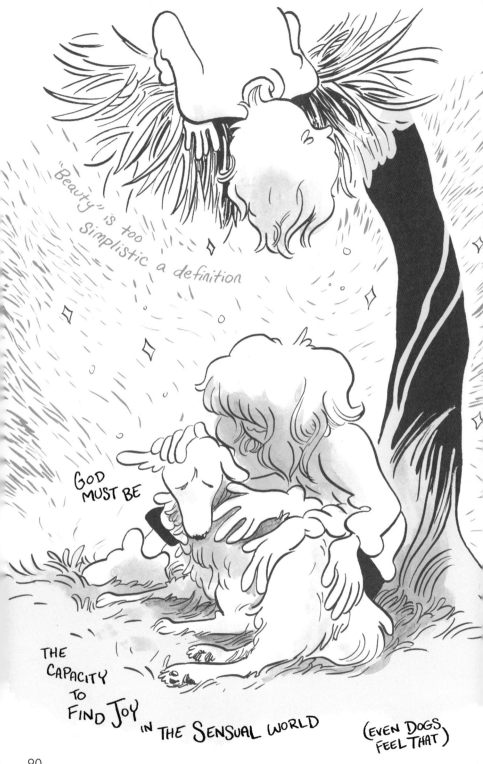

"Beauty" is too simplistic a definition

GOD MUST BE

THE CAPACITY TO FIND JOY IN THE SENSUAL WORLD

(EVEN DOGS FEEL THAT)

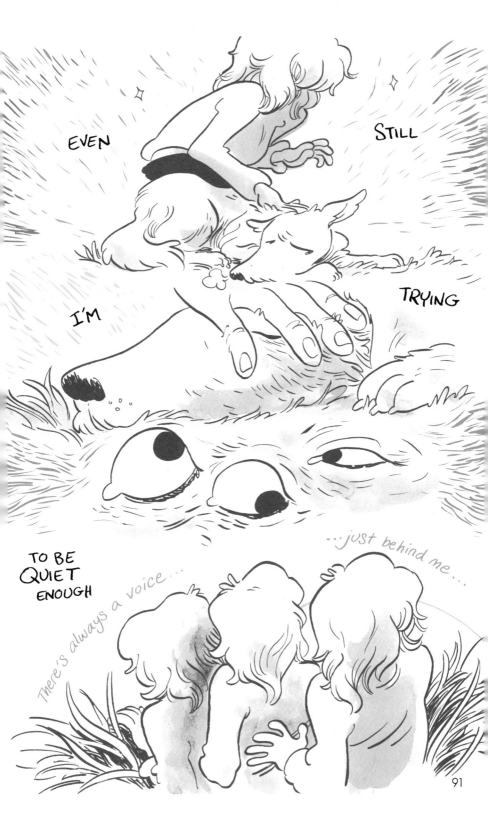

...but it always vanishes when I turn around

IT'S THERE

S... ME WHERE...

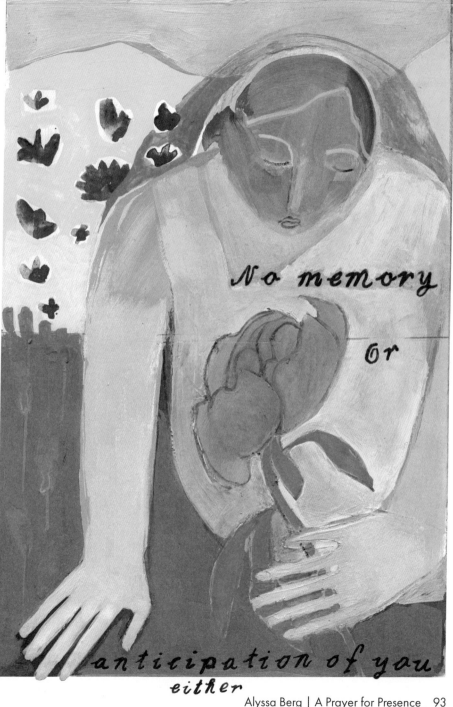

A prayer for presence:

No memory

or

anticipation of you either

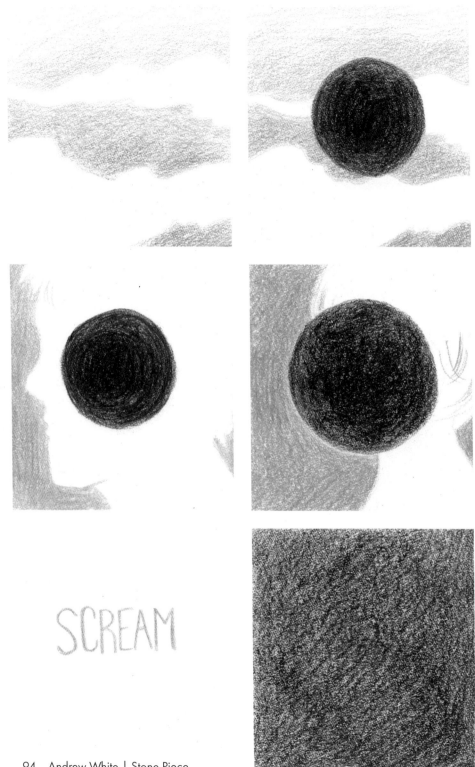

SCREAM

AGAINST THE WIND AGAINST THE WALL

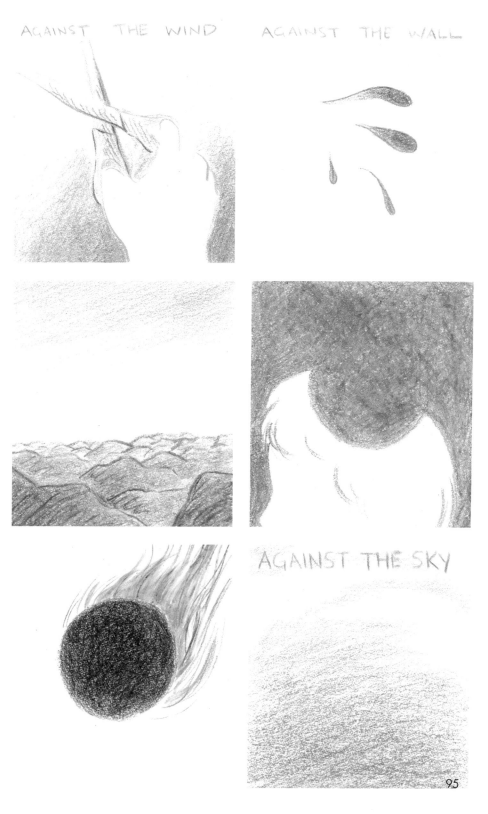

AGAINST THE SKY

95

THROW A STONE
INTO THE SKY

HIGH ENOUGH THAT IT WILL
NOT COME BACK

IMAGINE YOUR
BODY SPREADING
RAPIDLY ALL
OVER THE
WORLD

LIKE THIN TISSUE

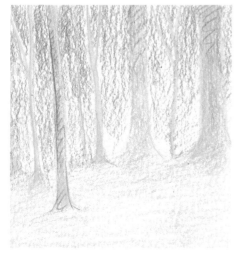

WHERE DO YOU WANT
TO SPEND ETERNITY?

98

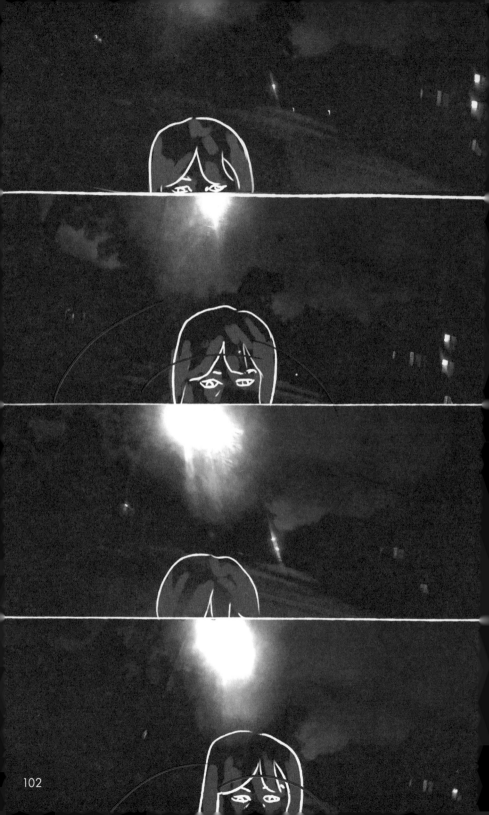

sometimes I get lost

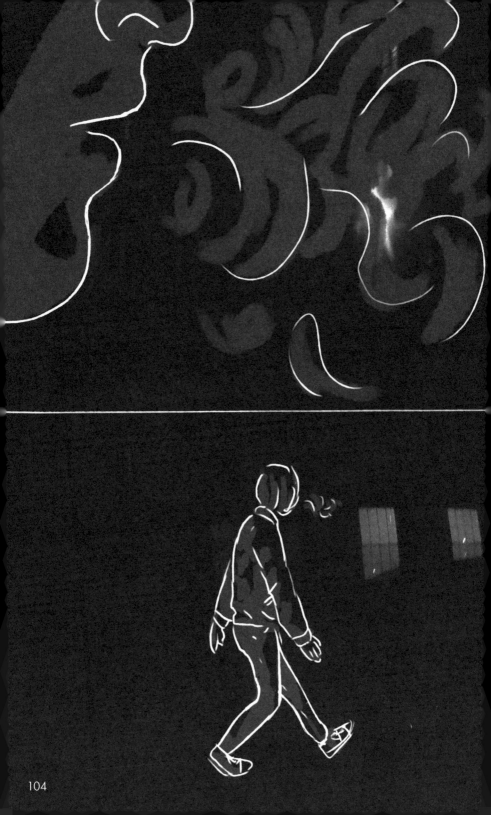

105

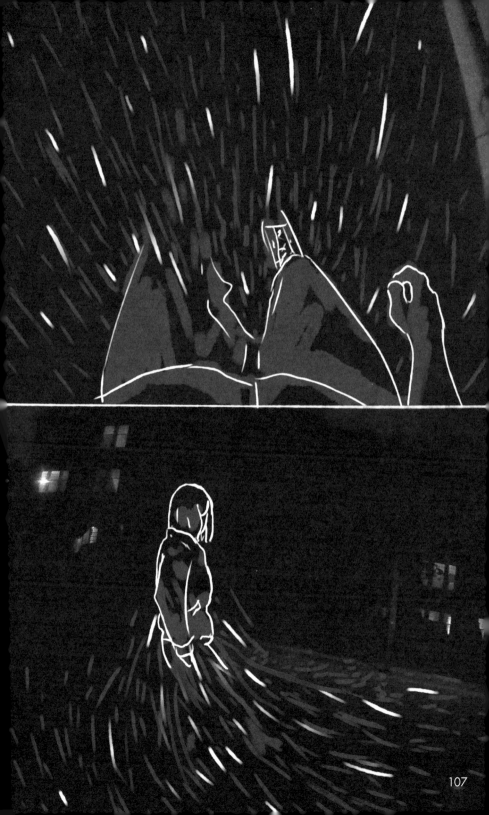

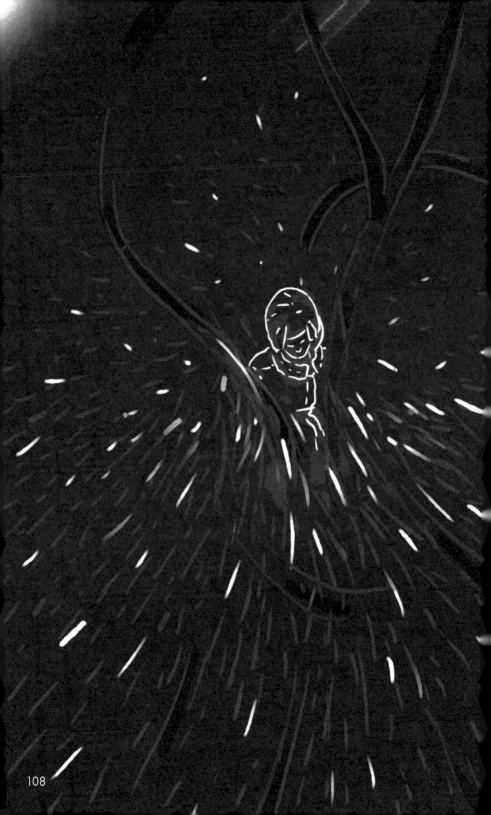

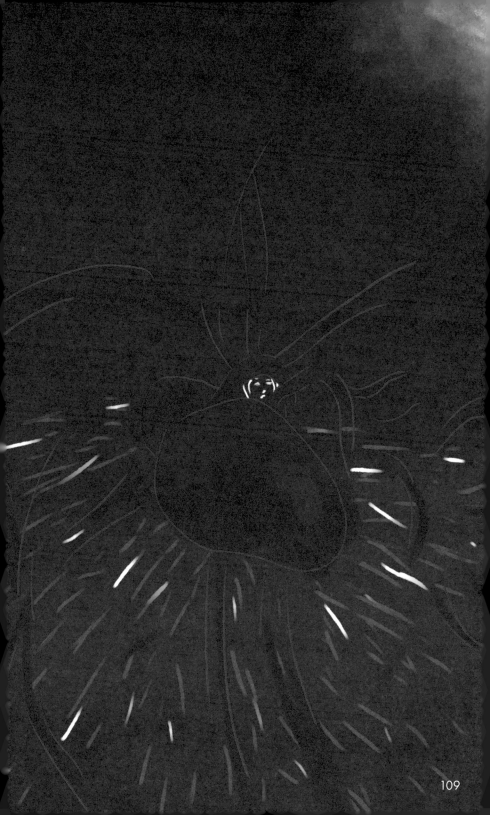

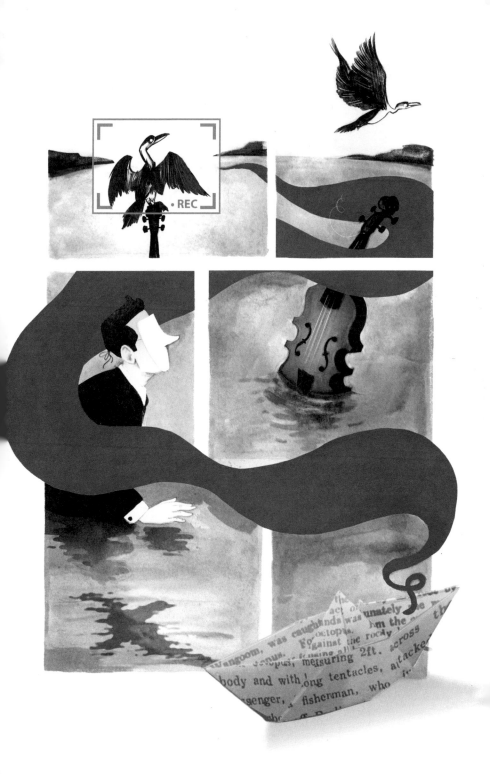

SNOW COUGH

You can draw a soul to sand and build a castle out of deer ticks.

You can pull the skin from my lips in dry, TRANSPARENT sheets.

113

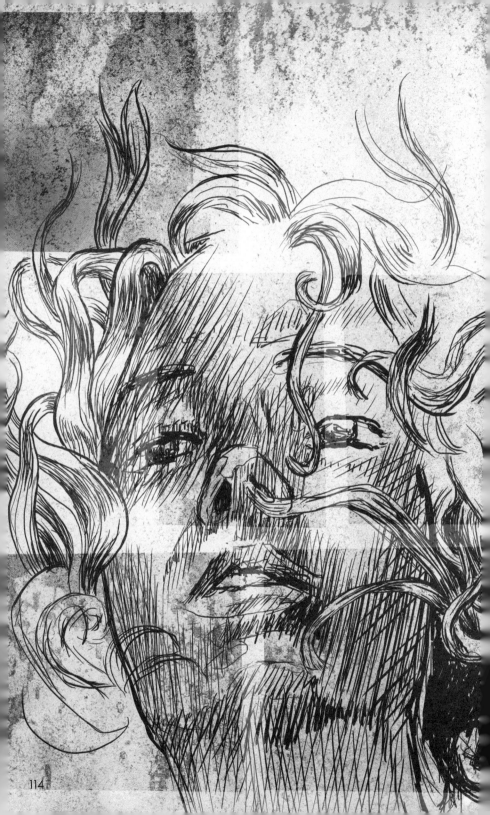

PURGE the snow tHAt fills our LUNGS -threatening to drown us if we get warm.

BUT IF I PROMISE not to BEG WOULD you

please draw more DODECAHEDRONS on my palms, shoulders & LEGS.

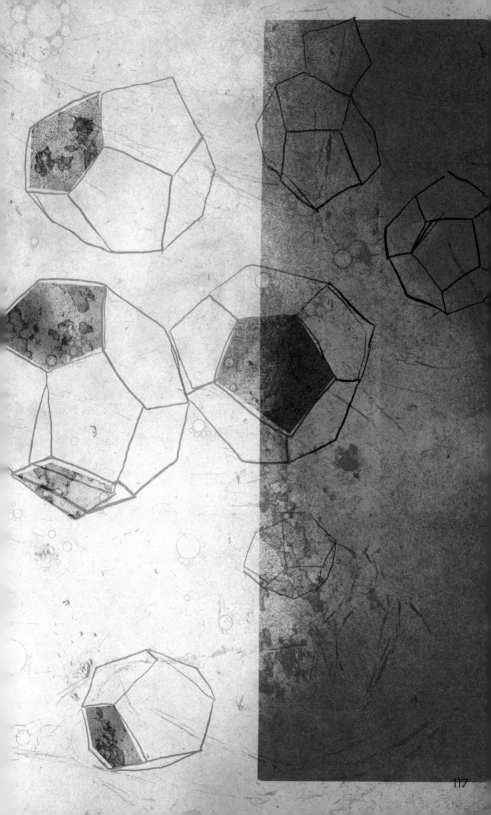

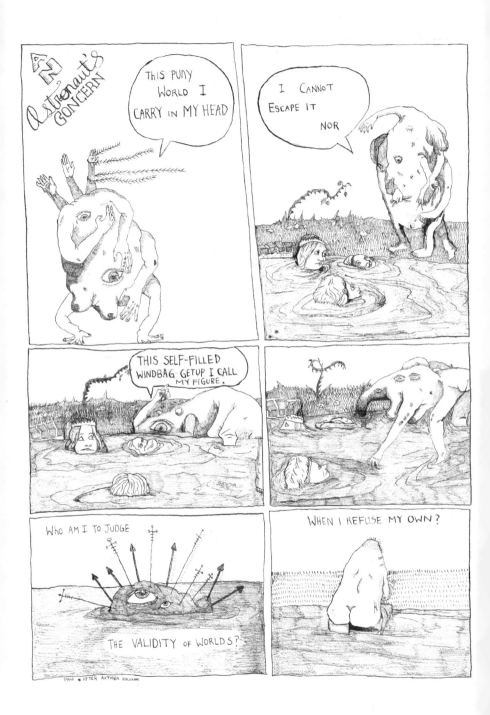

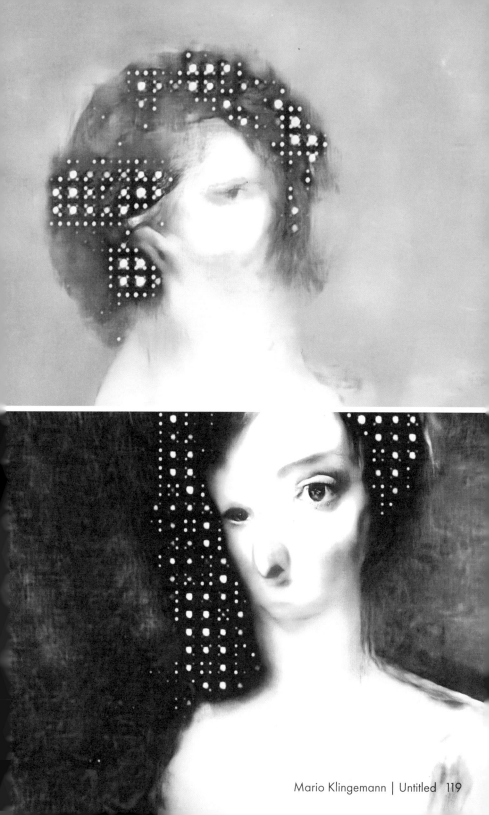

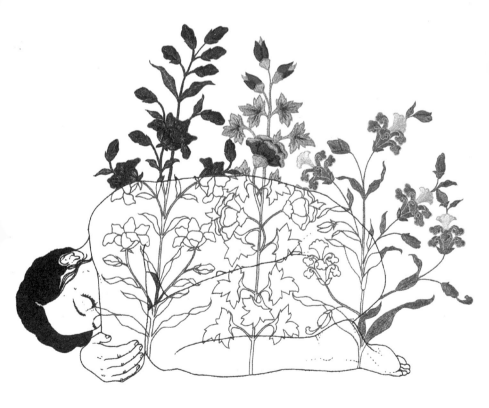

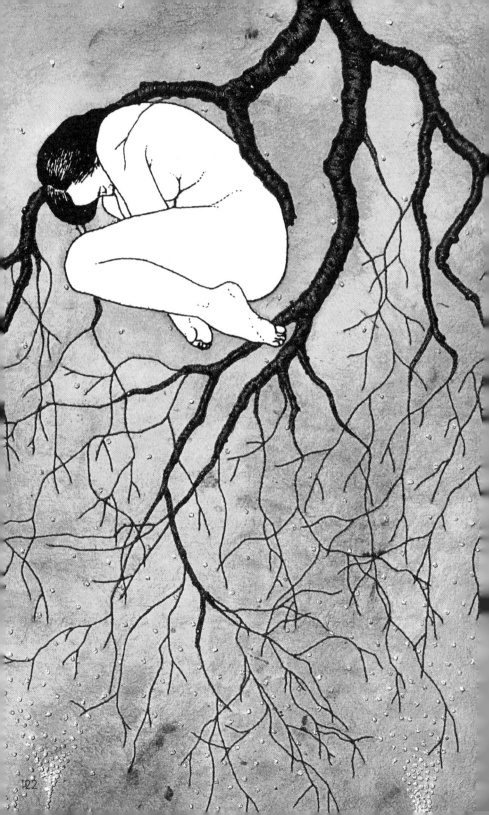

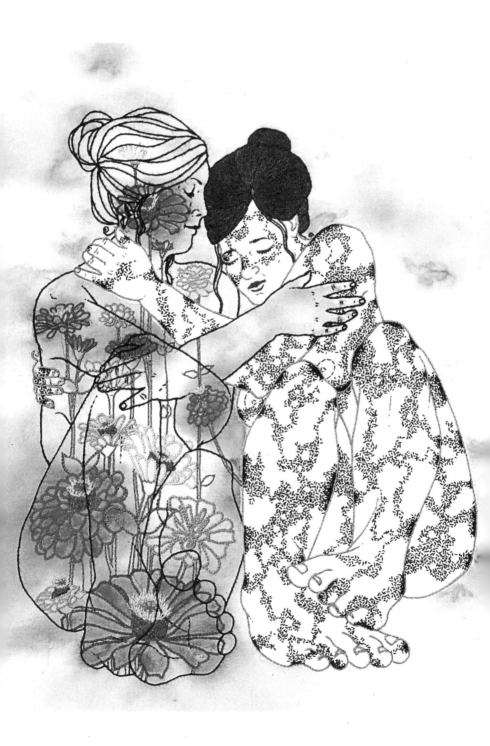

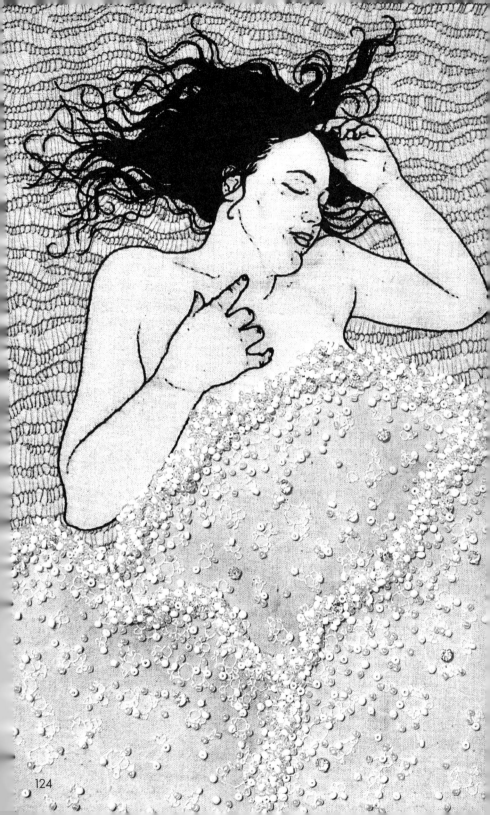

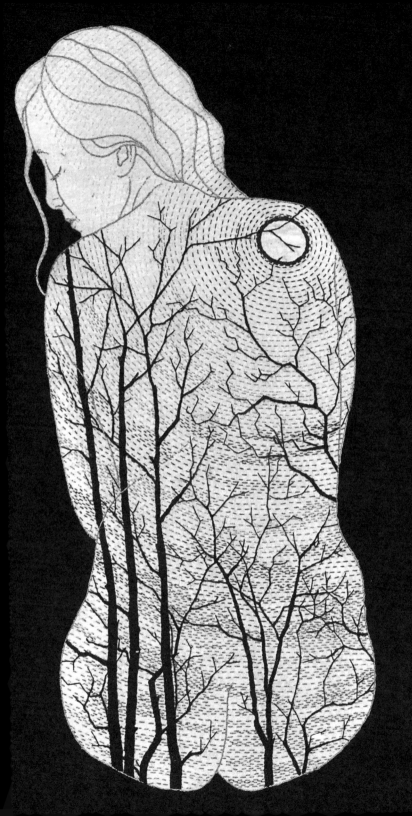

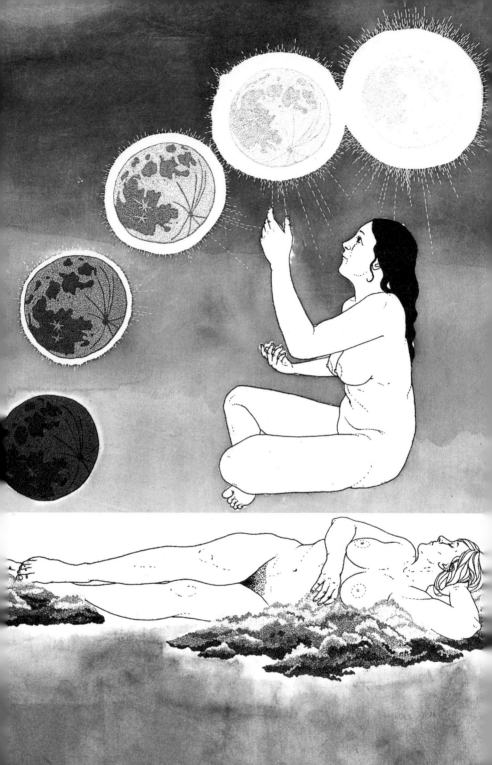

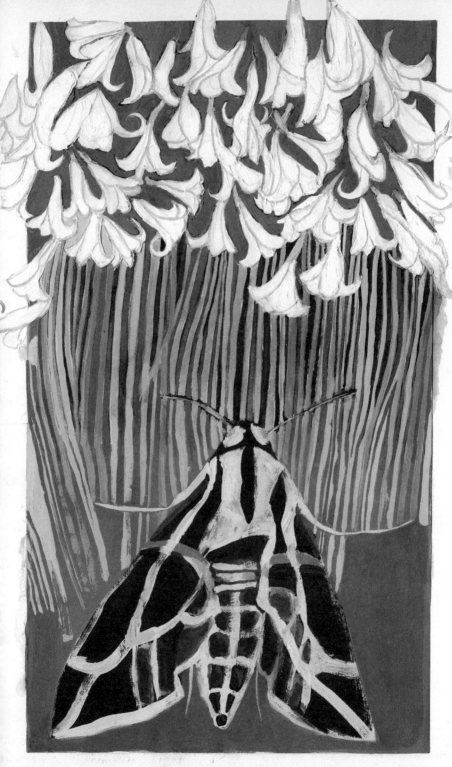

Y'ALL EVER SAT
IN THE DESERT?

I'M WONDERING IF
WHAT WAS TRUE
IN THE RIVER

COULD BE TRUE
HERE TOO

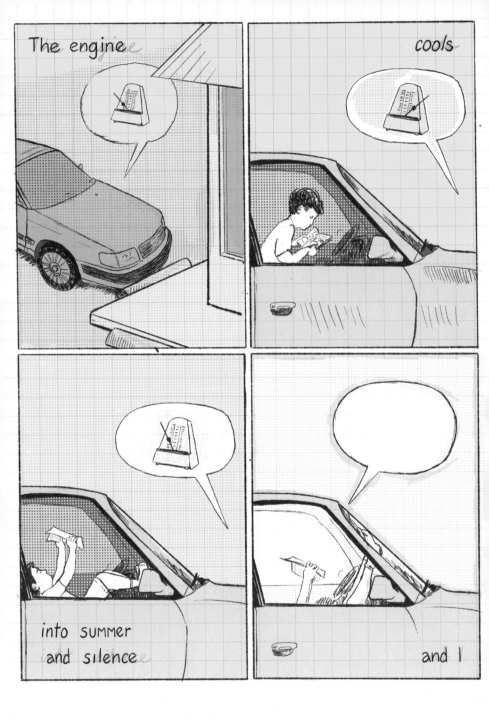

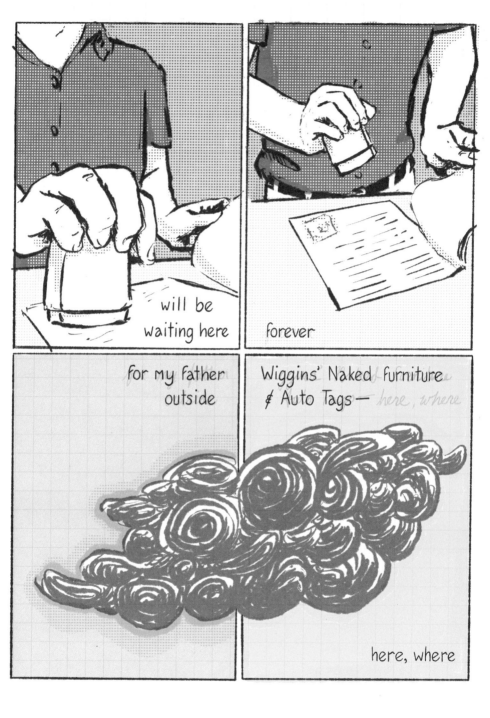

will be
waiting here

forever

for my father
outside

Wiggins' Naked furniture
& Auto Tags —

here, where

131

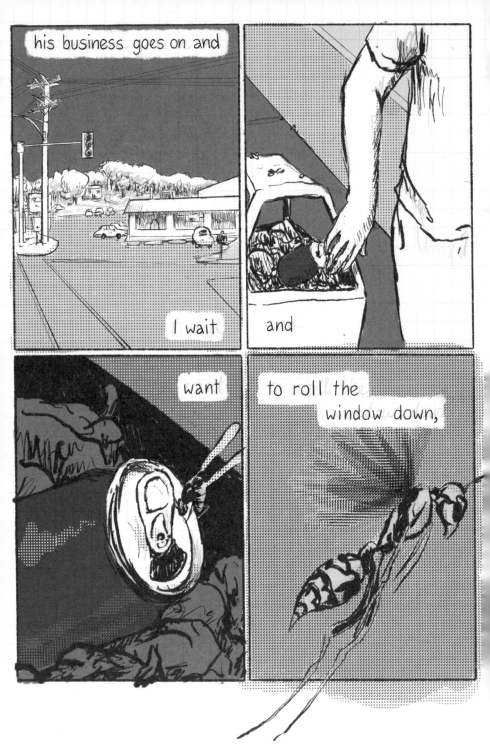

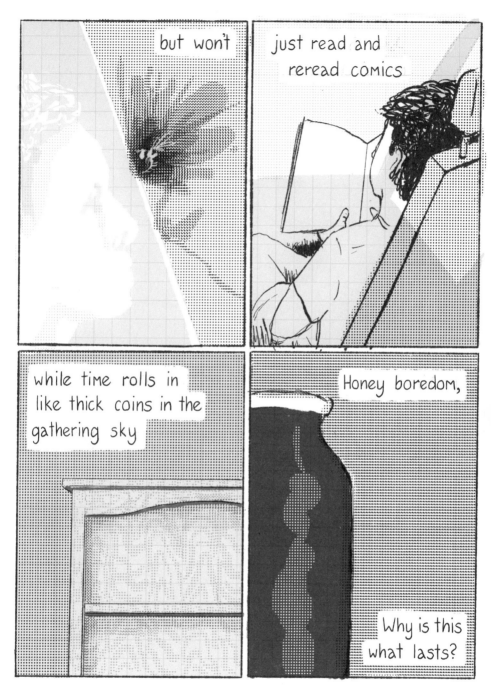

but won't just read and reread comics

while time rolls in like thick coins in the gathering sky

Honey boredom,

Why is this what lasts?

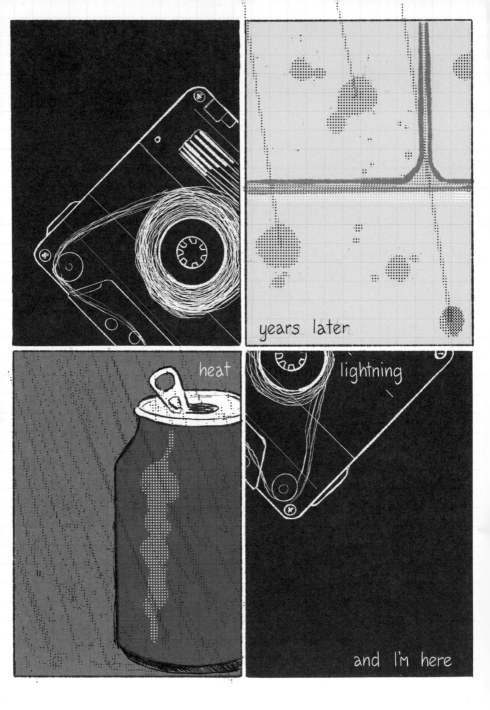

years later

heat lightning

and I'm here

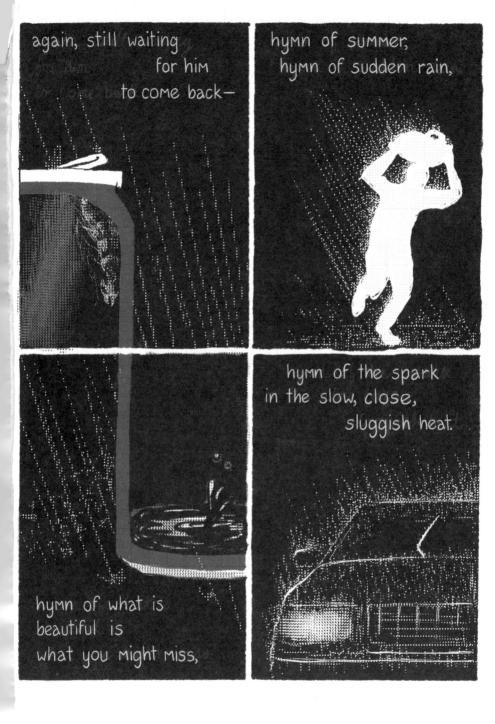

again, still waiting
for him
to come back—

hymn of summer,
hymn of sudden rain,

hymn of the spark
in the slow, close,
sluggish heat.

hymn of what is
beautiful is
what you might miss,

CONTRIBUTORS

KIMBALL ANDERSON does comics for people who fell off the conveyor belt of life. Their art probes at the parts of ourselves that we judge as not enough, too ambiguous, or too simple, honoring them as meaningful and beautiful as they are.
 outside-life.com

ALYSSA BERG is a Brooklyn-based artist who makes small-edition zines, comics, and art books.
 alyssaberg.com

WARREN CRAGHEAD III lives in Charlottesville, Virginia, USA with his wife and two daughters.
 craghead.com

KEVIN CZAP (pronounced "chap") is a cartoonist based in Providence, Rhode Island. They run the micro-press Czap Books, publishing comics celebrating the poetic, personal, and weird, in addition to copublishing the art-inspired, Ignatz-nominated series Ley Lines with Grindstone Comics.
 kevinczap.com

ALLIE DOERSCH is an unusual human living in Reykjavík, Iceland.
 doe.ink

AMANDA GREEN is an illustrator/storyteller who is currently studying comics at The Sequential Artists Workshop. Her mission is to share stories that help other humans feel better about being human.
 instagram.com/amandagillustration

THOMAS HAMLYN-HARRIS is an Australian writer, illustrator, and designer currently working on his first graphic novel, The Clockwork Bones.
 thhink.com.au

ILEANA HABERMAN-DUCEY is a queer artist who has been embroidering her own body as a way to convey the important moments and vulnerable emotions of her life for over a decade. In the last few years she has added comics to the list of ways to reflect on her experiences.
 instagram.com/m_ileana_art | meaganileana.com

JOHN HANKIEWICZ is a printmaker and cartoonist. His comics include Asthma (Sparkplug), Education (Fantagraphics), and numerous self-published booklets.
 hankiewicz.blogspot.com

EMMA JENSEN likes to draw, read, and swim, sometimes all at the same time.
 instagram.com/emmaleejensen

KEREN KATZ is the non-fictitious half of The Katz Sisters Duo as well as a member of The Humdrum Comics Collective in Tel Aviv, Israel. She enjoys writing and reading stories of unrequited love and magic schools. Her books are The Academic Hour and The Backstage of a Dishwashing Webshow.
 instagram.com/thekatzsisters

MARIO KLINGEMANN is an artist who uses algorithms and artificial intelligence to create and investigate systems. He is particularly interested in human perceptions of art and creativity, researching methods in which machines can augment or